FAIRIES
& FANTASY

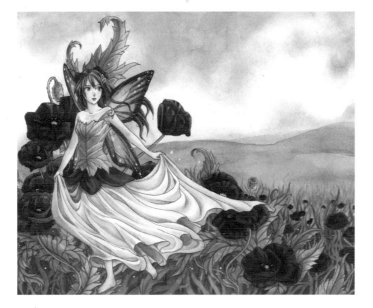

By Meredith Dillman

Walter Foster Publishing, Inc.
3 Wrigley, Suite A
Irvine, CA 92618
www.walterfoster.com

Project Editor: Elizabeth T. Gilbert • Designer: Shelley Baugh • Copyeditor: Meghan O'Dell

❖CONTENTS

⟡INTRODUCTION

Watercolor lends itself to fantasy illustration because artists can use it to create a variety of different effects and styles—from dreamy, abstract blends to intricate details. Because of its fluid nature, watercolor can often be intimidating for beginners; however, with some practice, you'll find this medium to be a very exciting and rewarding choice. Watercolors are also fume-free and very easy to clean up, and they require few extra tools.

Watercolor has a long relationship with fairy tale and fantasy art that dates back to the nineteenth century. Fairy tale illustrators, such as Arthur Rackham and Edmund Dulac, used watercolors or a combination of watercolors and pen and ink for their ethereal illustrations. The vibrancy of the paint also makes it a great choice for manga-style art.

This book provides information on materials, basic techniques, and instruction specific to creating your own fantasy paintings. You'll also find 12 step-by-step projects that will guide you from a drawing to a finished work of art, allowing you to practice your newfound skills. Soon you will be ready to create your own fairy world!

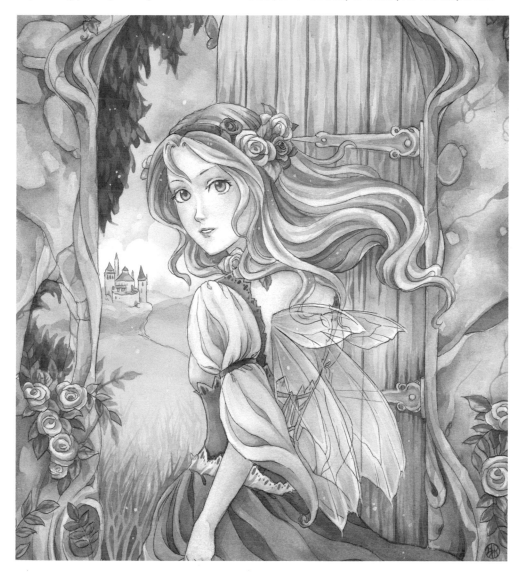

✤TOOLS & MATERIALS

DRAWING TOOLS

I prefer mechanical pencils to wood-encased pencils because the tips are fine and consistent, allowing for detailed drawing. I use H or HB leads for drawing, which are easy to erase and aren't likely to smudge.

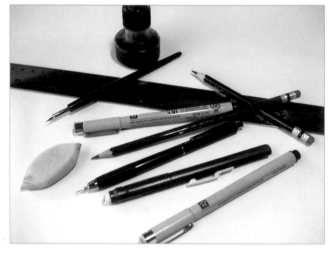

If you prefer more prominent lines in your paintings, you can use fine-point waterproof pens to outline your drawings before adding watercolor. Be sure to purchase waterproof pens, or the ink will bleed and affect your paint colors. It's a good idea to purchase a few sizes so you have a variety of line thicknesses to choose from. You may instead choose to work with dip pens, which—similar to calligraphy pens—consist of a holder and replaceable nib that can be swapped out for different sizes. To use these pens, dip the nib in a bottle of waterproof or acrylic ink and lightly tap off excess drops of ink before you stroke on the paper. Dip pens require quite a bit of practice to master; don't try using them on watercolor paper until you have learned how to avoid dripping the ink.

In addition to drawing instruments, it's a good idea to have a ruler on hand for drawing straight lines and an eraser for correcting mistakes and cleaning up any smudges.

PAPER

You can use sketchbooks for recording and exploring ideas, but loose paper is best for planning future paintings. Once you've sketched and refined the drawing on a sheet of paper, transfer it to watercolor paper (see box below). Watercolor papers come in rough and smooth varieties. Rough paper is commonly labeled "cold press," and smooth paper is labeled "hot press." Cold-press paper is textured and works well for large and loose paintings, whereas hot-press paper's untextured surface lends itself to illustration and small details. Each brand of paper varies in texture, so it is important to try a few and find out which type best suits your style.

TRANSFERRING A DRAWING

At the beginning of each project, you'll find a line drawing of the scene that you can photocopy, enlarge, and use to transfer the image to your watercolor paper. Here are two ways you can go about transferring a drawing:

- Use a light box, which is a special desk or inexpensive box with a transparent top and a light inside. The light illuminates papers placed on top and allows dark lines to show through for easy tracing. You can also improvise by placing a lamp under a glass table.

- Place a sheet of carbon or graphite paper (face down) beneath your drawing; then place these over a sheet of watercolor paper. Carefully tracing over your drawing will transfer the lines to the watercolor paper. If you don't have graphite paper, you can create it by coating one side of a sheet of drawing paper.

WATERCOLOR PAINTS

Watercolors are available in pans or tubes. Pans, which are dry or semi-moist cakes of pigment, are best for travel or outdoor painting. Tubes, which contain moist, squeezable paint, are great for creating large quantities of a color. Both types of watercolor may be found in sets or individually. You'll find a wide range of prices for watercolors, but remember to purchase the best you can afford. There are two grades of watercolor available: artist quality and student quality. Artist-quality paints (the more expensive grade) are made with a higher ratio of natural pigments to binders, so they are generally more concentrated and brighter in appearance. Student-quality watercolors use more synthetic pigments or mixes of several types of pigments. These are fine for beginners, but you'll achieve more satisfaction in the long run with artist-quality paints.

Each paint color usually has a lightfast rating of I, II, or III on the label. This rating refers to how much a color will fade under sunlight. A rating of I is the most permanent and III is the least. I try to use paints that fall under I or II. Certain common colors such as alizarin crimson are known for fading, but permanent substitutes are now available (just look for "permanent" in the name).

Colors used:

Alizarin crimson (permanent)	Cadmium yellow	Napthol red	Quinacridone violet
Burnt sienna	Cobalt blue	Payne's gray	Sap green
Burnt umber	Dioxazine purple	Phthalo blue	Sepia
Cadmium orange	Hooker's green	Phthalo green	Titanium white
Cadmium red	Lamp black	Quinacridone red	Yellow ochre

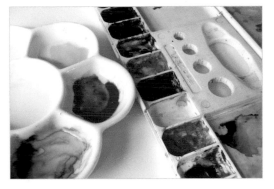 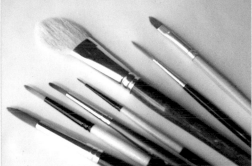

PALETTES

Porcelain palettes (above left) for watercolor are common and easy to clean. I use a plastic fold-up palette (above right) and fill each compartment with a color using my tube watercolors. I can simply close the lid for easy transportation. When my colors run out, I squeeze more paint into the wells. The watercolor paints may eventually dry, but they can easily be reactivated with water.

ADDITIONAL TOOLS

You will need a selection of other useful tools, such as a container for water; a bottle of masking fluid; and paper towels for cleanup, blotting your brushes, or painting. You may also want to purchase artist's tape to secure your paper to a drawing board or painting surface. This type of tape is easy to peel away and won't damage the paper.

PAINTBRUSHES

Brushes can be made from animal hair, synthetic fibers, or a combination of the two. Sable-hair brushes are the most expensive, but synthetic brushes are good for most uses and come in just as many shapes and sizes—round, flat, and mop, as well as specialized chisel and fan shapes. Round brushes are versatile and taper to a tip so they can be used for a variety of stroke thicknesses. (When buying a round brush, make sure the bristles form a pointed end and the hairs spring back when you run a finger across them.) Flat and mop brushes are used for laying down large areas of color. A rigger brush is a long, thin-haired round brush used to create fine lines.

I use mostly small round brushes for my work. Round brush sizes are indicated by a number; the larger the number, the larger the brush. Sometimes the number system can vary between brands, so just remember to have an array of small round brushes on hand as you complete the projects.

✤COLOR THEORY

THE COLOR WHEEL

The color wheel (at right) shows how color pigments relate to one other. Red, yellow, and blue are *primary* colors and cannot be created by mixing any other colors. *Secondary* colors are mixed from two primary colors and include orange, green, and purple. Colors directly across from each other (e.g., blue and orange) are complementary colors. *Tertiary* colors are made by mixing a primary color (e.g., red) with a secondary (e.g. purple) to make red-violet. If you mix the three primaries together in varying proportions, you'll get a range of neutrals (browns, grays, and even blacks).

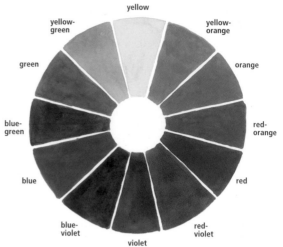

yellow
yellow-green
yellow-orange
green
orange
blue-green
red-orange
blue
red
blue-violet
red-violet
violet

COLOR SCHEMES

Color schemes are combinations of colors that create various effects in a painting—from unity to dynamic contrasts. Each color scheme garners a different response from the viewer, so you'll want to think about your subject and the atmosphere you want to convey. Familiarize yourself with the common color schemes below.

Monochromatic Monochromatic paintings are made up of variations of one color, such as the purple painting at left. A pencil drawing or a black-and-white photograph, however, are called "achromatic."

Primary A primary color scheme uses the three primary colors: yellow, blue, and red.

Analogous This color scheme uses a series of three to five colors next to one another on the color wheel. In this example, I use yellow-green, green, and blue-green.

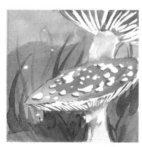

Complementary Placed next to each other in a painting, complementary colors make each other appear brighter, which makes for a vibrant color scheme.

Split Complementary This uses one main color and the colors adjacent to its complementary color. In this example I use yellow, red-violet, and blue-violet.

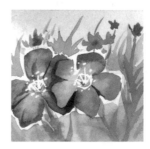

Triadic Uses three colors that are equally distant from one another on the color wheel. In this example, I use violet, green, and orange, resulting in a strong contrast.

✦PAINTING TECHNIQUES

Before beginning the step-by-step projects, explore the ways you can apply and manipulate watercolor paint.

Flat Wash For this basic technique, cover your paper with horizontal bands of even color, starting at the top and working your way down.

Graduated Wash Load your brush and apply overlapping strokes, adding water with each consecutive stroke. The color will gradually thin out as you continue.

Variegated Wash This is similar to a graduated wash, but it involves blending from one color into another.

Wet in Wet For this technique, paint over still-wet areas so the colors bleed together or blur. Drips of color or clear water on wet areas are useful for creating texture.

Soft and Hard Lines For a hard line, paint a dry stroke on dry paper. Any line can be softened by blending the edge with clear water before it dries. This is useful for areas where detail is not needed.

Spattering Hold a loaded brush over your paper and lightly tap the brush with your finger. This can also be done with clear water over a still-wet color. (Practice this technique before applying it to a painting.)

Negative Painting Negative painting involves painting around the desired shape rather than painting the shape itself. Instead of painting a leaf, paint the area around the leaf.

Salt Using salt with watercolor can create sparkly effects or a mottled texture. Simply sprinkle salt over a freshly wet wash. When dry, gently rub off the salt.

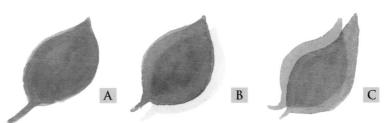

A B C

Color Glazing Rather than mixing each color, it's possible to layer transparent colors to create a new color. This technique, called "glazing," adds a distinct glow and depth to your painting because the color is mixed optically on the paper (B) rather than in the palette (A). Let each layer dry before adding another color. Also, it's important not to use a brush that's too wet, or you may disturb the previous layers. In addition to color mixing, you can darken areas that stand out too much by glazing over them. Any complementary color glazed over another (C) will make the color darker. You can do the same using a cool color (blues, greens, and purples) over a warm color (reds, oranges, and yellows) or vice versa.

Masking Fluid Masking fluid is liquid latex that allows you to protect areas that you want to remain white in an otherwise dark picture. Paint the area you want with the masking and let it dry. To remove it, rub it off with your fingers. Since it can be difficult to remove from brushes, use an old brush or a rubber-tipped brush for thin lines.

DRAWING THE FIGURE & HEAD

When drawing a human figure, perhaps nothing is more important than achieving accurate proportions. *Proportion* refers the relationship of one part of the body to the rest; if these ratios are off, the figure will appear unrealistic. Below are several ways to check your figure's proportions for accuracy.

THE BODY

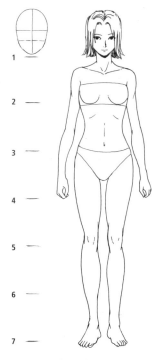

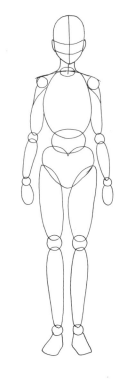

◄ The height of a figure is usually 7 to 8 head lengths tall.

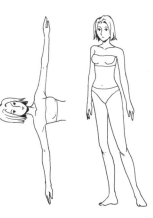

▲ If a person holds out her arms to both sides, the length between the tips of each hand is approximately equal to her height.

THE HEAD

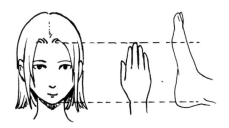

▲ The length of a hand (from the bottom of the palm to the fingertips) is equal to the space between the chin and the end of the forehead. The foot is a bit longer than length of head, and the hand is 2/3 the length of the foot.

▲ Keep in mind the following alignments as you add the features: The space between the eyes and eyebrows is one eye width. The tops of the eyes line up with the tips of the ears. The bottom of the nose lines up with the bottoms of the ears. The outer edges of the nostrils line up with the inner edges of the eyes. The ends of the mouth line up with inside edges of the irises when the subject is looking straight ahead.

STEP-BY-STEP HEAD: FRONT VIEW

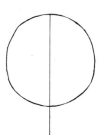

◄ Step 3 Draw an arrow shape at the bottom of the vertical line. Connect the arrow to the circle with two lines. These indicate the sides of the face and should be at a slight slant.

▲ Step 1 Start the head with a simple circle.

▲ Step 2 Draw a line about 1¹/₂ times the circle's width down the center vertically. The bottom will mark the position of the chin.

◄ Step 4 A horizontal line along the bottom of the circle shows where to place the bottoms of the ears and nose. The tops of the ears are about ¹/₃ of the way up the circle. This line also marks the centers of the eyes.

▲ Step 5 Place the eyes and nose on the correct guidelines, as shown above. The distance from the bottom of the nose to the bottom of the mouth about is one eye width.

STEP-BY-STEP HEAD: PROFILE VIEW

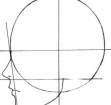

◄ Step 3 Draw two lines intersecting the circle. These lines will show where to place the ear. Add a curved line for the jaw from the outer vertical guideline to the bottom center of the circle.

▲ Step 1 Start again with a simple circle.

▲ Step 2 Draw a line about 1¹/₂ times the circle's width against the side at a slight angle.

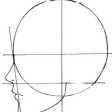

◄ Step 4 Draw profile features along the outer guideline. Horizontal lines mark the positions of the tops and bottoms of the nose and ears.

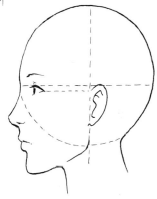

▲ Step 5 Add the rest of the features. Place the eyes in line with the top of the ear.

STEP-BY-STEP BODY

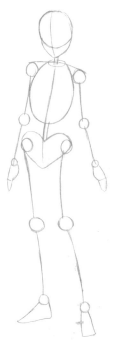 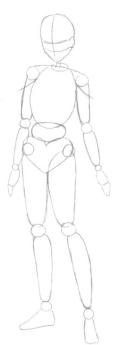 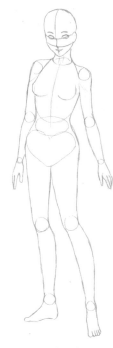 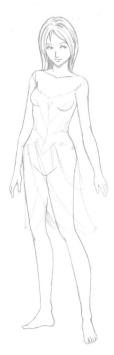

Step 1 Sketch the body using a simple skeleton. Represent the head, rib cage, pelvis, and feet with simple shapes. Use small circles for the joints.

Step 2 Draw simple shapes in place of the skeletal lines and erase the lines. Add guidelines on the head.

Step 3 Place facial features on the head. Using the underlying shapes and guidelines, smooth the outline of the body. Draw fingers and toes.

Step 4 Erase the guidelines and add details as you refine the outermost lines.

FROM REALISM TO MANGA

Manga is the word for comics in Japanese. Manga and Japanese animation (called "anime") are usually characterized by cute, wide-eyed characters, but there are many variations in style. Hairstyles and colors can be almost anything you may dream up. Manga artists use large eyes to allow for more expression, tiny bumps for noses, and many other distinct characteristics, but remember that there are many degrees between manga and realism. To develop your own style, look at a variety of art for ideas.

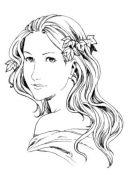 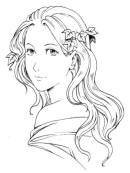 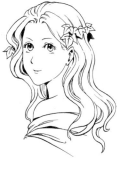

Realism This drawing shows a girl's face with proportions similar to those of a real person. The examples at right will illustrate manga principles applied to this drawing.

Partially Manga Here the eyes are slightly larger, the face and chin are slightly rounder, and there is less of a line around her lips and nose. Much of manga art uses *implied line*, which relies on the human eye to fill in what is missing.

Full Manga Here the face is rounder by bringing the cheekbone lower. The eyes are larger and more expressive; the mouth is smaller and cuter; (the bottom lip is just suggested); and the nose is smaller (just the tip is outlined). Hair detail is minimal.

DRAWING EYES

A manga eye is drawn like a normal eye, but there are a few differences that give it a special flair. A manga eye is larger and involves minimal outlining of the outer edges. Light reflections are usually exaggerated, and the iris may stretch to an oval instead of a circle.

▶ Here I've drawn two eyes step by step; the left column shows the development of a normal eye, and the right column shows the development of a manga-style eye. Begin by drawing curved lines for the top and bottom lids (A). Add a line for the crease over the top of the eyelid and outline the iris (B). Indicate the pupil. Draw a small circle between the pupil and iris to represent a reflection, keeping in mind the direction of light (C). Add eyelashes on the upper outer lid. Next detail the iris with radial lines. Remember that the top of the iris is darker than the bottom due to a cast shadow from the upper eyelid (D). Finalize your drawing with ink, leaving the highlights white (E).

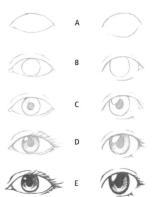

Because eyes are usually the most important part in a manga face, it's a good idea to practice a variety of styles. They can be highly detailed and realistic or just a few simple lines. Below are some examples.

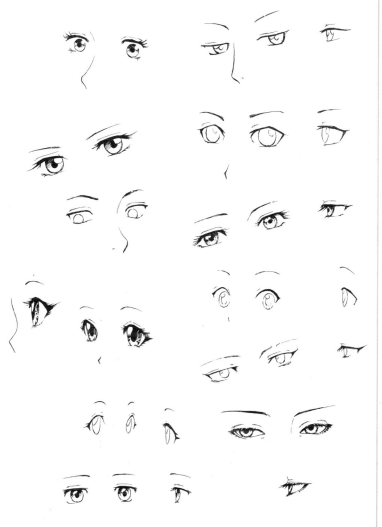

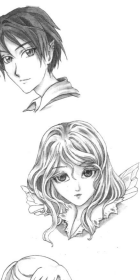

▲ Younger characters have large, round, expressive eyes or very long eyelashes. An evil character may have smaller, thinner eyes.

TYPES OF FANTASY FEMALES

Many of the names for fairies come from ancient Greek or Welsh languages and are personified aspects of nature. Because many cultures have similar fairy stories, there are many names for each kind of fairy.

 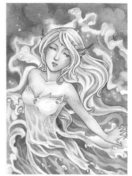

Dark Fairies Dark fairies are part of the Unseelie Court from Scottish mythology. These ladies travel only at night and are unkind to humans. Dark fairies may be ugly, evil, or beautiful, and they may inhabit dark places like caves and abandoned ruins. A Will-o'-the-Wisp is a mischievous spirit who appears at night as a light hoping to mislead travelers, taking the shape of a lantern or a glowing fairy.

Wood Fairies Wood or forest fairies inhabit trees and forests. Dryads are wood nymphs who look over forests. A Hamadryad is similar to a Dryad, but she is connected to the life of the oak tree she inhabits. Both are shy creatures that don't wander far from their trees and often blend into their woody surroundings, making them hard to spot.

Flower Fairies Flower fairies are small, benevolent fae who inhabit gardens and fields. They are usually connected to one particular plant or flower and may even resemble it. These little fairies have insect wings—a fairy characteristic made popular in Victorian literature such as *Peter Pan*.

Elemental Fairies Elemental fairies are associated with one of the elements—earth, fire, water, or air. They may be partially made of their element, or they may appear as humans. Sylphs are air elementals who may be invisible or hard to see. A Salamander is a fire elemental and a gnome connected with the earth. Water nymphs (shown above) go by many names, such as mermaids, Undines, Nixies, and Nareides.

ANGELS AND MERMAIDS

Just like fairies, angels and mermaids don't have to be painted with the usual white wings or blue tails. Look to birds and tropical fish for colorful and creative ideas. Angel wings may be drawn with detailed feathers or just a simple suggestion of feather shapes. Mermaid tails can be based on different types of fish or even seaweed. For a feminine blend of fantasy worlds, you can make the fins resemble the wings of fairies.

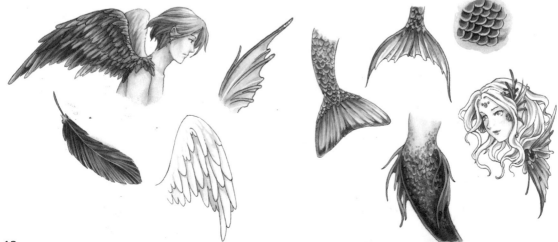

FAIRY FASHIONS

The clothing you choose for your fairy will help establish time and place in your fantasy scenes. The most common themes are shown below, but remember there's no limit to what you can do!

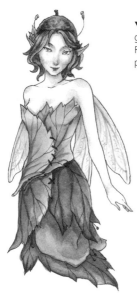

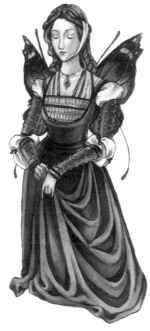

▼ **The Historical Look** Dress based on historical costumes will give your fairy a regal look. Inspiration can be found in anything from Renaissance portraits to Victorian fashion plates or ancient Chinese paintings. Visit a local museum or library for ideas.

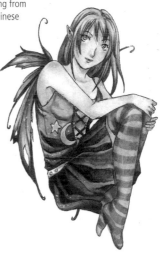

▲ **The Natural Look** Dressing your fairy in costumes based on or made of plants gives them a traditional, earthy look. Flowers flipped upside down can be adapted into skirt or dress designs, and small flowers, acorns, and leaves can be made into hats.

▲ **The Modern Look** Fairies don't have to live in the past. You can dress your fairy in modern clothing or mix modern styles with traditional attire—or even get ideas from futuristic science fiction costumes. Short skirts, T-shirts, platform boots, and striped stockings are common additions.

CHOOSING WINGS

Just like fairy outfit possibilities, there are many different types of wings to choose from. First decide which kind of fairy you are drawing, as well as the setting and season; then match the wings to their costume and the rest of the picture. Wings made out of leaves and twigs will fit on a wood fairy or Dryad. A flower fairy is suited for small insect or butterfly wings. A dark fairy's wings may be ragged or resemble a bat's wings. An elemental fairy can have wings made from water, ice, or fire. But remember that not *every* fairy needs to have wings. And for extra creativity, try mixing different wing elements.

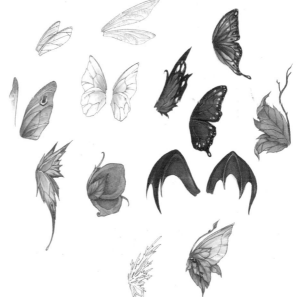

✤CREATING BACKGROUNDS

The setting of your fantasy scene is important for creating an inviting piece of artwork. Whether you're painting a medieval castle in the sky or a stone pathway in a forest, chances are you won't have the scene in front of you to reference. For this reason, it's a good idea to collect images of scene elements for studio reference.

TAKING PHOTOS

A camera is a great tool for an artist. Not only can you take photos of yourself or friends for figure references, but you can also easily collect ideas for background elements. Carry a camera with you as often as possible, or take special trips to photograph buildings and nature—dramatic doorways (A), elaborate stonework (B), mushroom sprouts (C), foliage (D)—anything that catches your eye. I find that a walk through the forest can be especially inspiring.

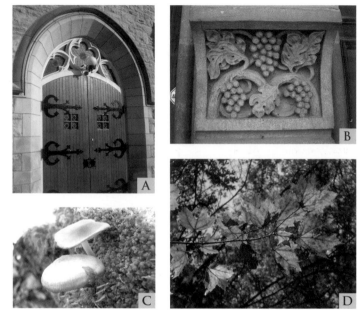

COLLECTING FLOWERS AND LEAVES

If you aren't able to take photos, you can collect fallen leaves, acorns, flowers, and mushrooms. Just make sure you have permission to pick them; some plant species are endangered and protected by law. You can dry your leaves and flowers by pressing them between the pages of a heavy book and leaving them to dry. (Place clean paper on both sides of the book to protect the pages.)

KEEPING A SKETCHBOOK

Carry a sketchbook with you and draw scenes, wildlife, and plants that inspire you. If you collect leaves and flowers, you can record them in your sketchbook before they wilt. A sketchbook is also good for sketching thumbnails and ideas for paintings. If you have an idea you think you may forget, write it down or sketch it to refer to later.

ELEMENTS FOR FAIRY ENVIRONMENTS AND DWELLINGS

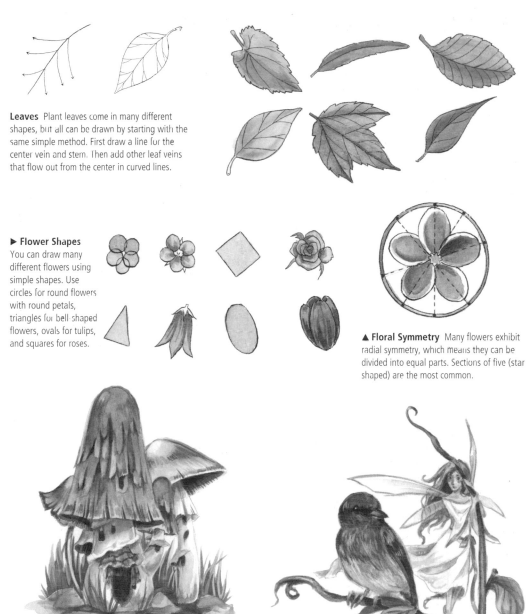

Leaves Plant leaves come in many different shapes, but all can be drawn by starting with the same simple method. First draw a line for the center vein and stem. Then add other leaf veins that flow out from the center in curved lines.

► Flower Shapes You can draw many different flowers using simple shapes. Use circles for round flowers with round petals, triangles for bell-shaped flowers, ovals for tulips, and squares for roses.

▲ Floral Symmetry Many flowers exhibit radial symmetry, which means they can be divided into equal parts. Sections of five (star shaped) are the most common.

Castles and Fairy Homes Fairy tale castles and ancient ruins make wonderful settings for fantasy paintings. History books and Renaissance paintings are great references for architecture. Small fairies may live in homes made from toadstools or holes in trees. Their belongings would be made of natural things like twigs, leaves, flower petals, dried mushrooms, and acorns.

Fairy Friends Celtic fairies are said to have their own horses, dogs, and cattle that are fairy-like and magical. Small animals like mice, birds, butterflies, and other insects are likely companions for diminutive fairies. But don't expect fairies to get along with a house cat!

✤COMPOSITION

Where you choose to place your figure in a composition is important for creating a believable scene where the figure interacts with her environment. It is a common mistake of beginners to completely finish drawing characters without having an idea of where they are or what they are doing. Because adding a background to a completed scene is challenging and often looks like an afterthought, think about where the person will be before finishing the drawing. Is your figure sitting or standing on something? Is your figure looking at something or someone?

FOREGROUND AND BACKGROUND

The background plays a large role in setting the mood of a piece. The foreground (the area in front of your character) is just as important; adding elements in this field will make the painting more realistic by providing a sense of depth. If your figure is walking through a thick forest, add some leaves and branches in front of her and behind her to convey the atmosphere. Because foreground elements are closer to the viewer, make them more detailed than elements in the background.

FOCAL POINTS AND DIRECTIONAL LINES

The *focal point* is the center of interest in your artwork. It may be your character's face, something she is looking at, or something she is traveling toward. Once you've decided where this is, construct the rest of the composition to lead the eye toward this point.

Directional lines are imaginary lines in a scene that point toward the focal point. A path leading up to a castle in the background is an obvious example of a directional line, but these lines can be as subtle as the direction a tree grows or the way a cloak blows in the wind. In the painting at right, observe the way the directional lines of the tree bark, skirt, and wings point to the center of interest—the fairy's face. These directional lines also add a sense of movement to an otherwise still picture. While drawing figures in action can be complicated, small details like the criss-crossing of directional lines, leaves blowing in the wind, and the direction of characters' faces all work together to create movement.

COMPOSITIONAL SHAPES

The most common shapes you'll find in dynamic drawing and painting compositions are the pyramid (A), the "S" (B), and the "X" (C). Pyramid-shaped compositions—bottom-heavy designs that peak at the focal point—were standard for paintings during the Renaissance.

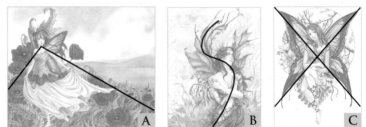

S-shaped compositions use curving lines to wind the eye toward an area of interest. An X-shaped composition uses criss-crossing directional lines to draw the eye toward the center of the X.

COMPOSITION TIPS TO REMEMBER

- Don't draw a person standing directly in the middle of the page looking straight ahead. Also, try not to cut off feet or body parts at the edge of the paper.
- A completely symmetrical composition is usually boring. Even a little asymmetry adds interest.
- The viewer will follow where your character's face and eyes are directed.
- Use variety in shape, size, and height of background elements.

BAD VS. GOOD COMPOSITION

▶ **Bad** The girl is looking straight ahead, the ground is flat, and the trees are mirrored. Overall this symmetrical composition is uninteresting.

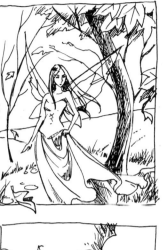

◀ **Good** Move the focal point closer to the viewer and off to the side. One tree is now closer, and there are some larger foreground elements for depth. The line from her skirt to the tip of one wing is a directional line, which crosses over the tree.

▶ **Bad** The focus of this image should be the castle. Although the path leads the eye in this direction, the clouds and taller mountain in the distance compete with it for attention.

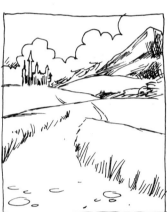

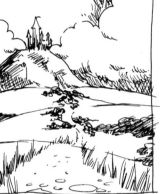

◀ **Good** By placing the structure on the highest peak and using the lines of the clouds to point to it, the castle becomes clearer as the center of interest.

PERSPECTIVE

There are two kinds of perspective: atmospheric and linear. *Atmospheric perspective* mostly relates to landscapes. When looking far into the distance, the buildings or mountains that are farthest away appear paler and closer to the color of the sky. This is caused by particles in the air blurring and muting the objects. *Linear perspective* is used to create realistic buildings within a space or to relate objects in a scene to one other.

The *horizon line* represents the eye level of the viewer. The viewer can see the tops of objects below eye level but not the tops of buildings or tall objects above this line. In one-point perspective (shown below), the *vanishing point* (the point at which all receding lines meet) will be on the horizon line. Objects appear smaller as they move toward this point. If we draw a line from the front of the canvas to the vanishing point, all objects fall on this line.

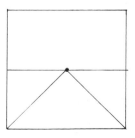

This image shows the horizon line and one vanishing point.

Use the previous image to construct a road and a line of trees receding into the distance.

To make a room, place a smaller box inside the square and remove the horizon line.

Place objects in the room by making all receding lines meet at the vanishing point.

✦ PROJECT 1: FAIRY FRIENDS

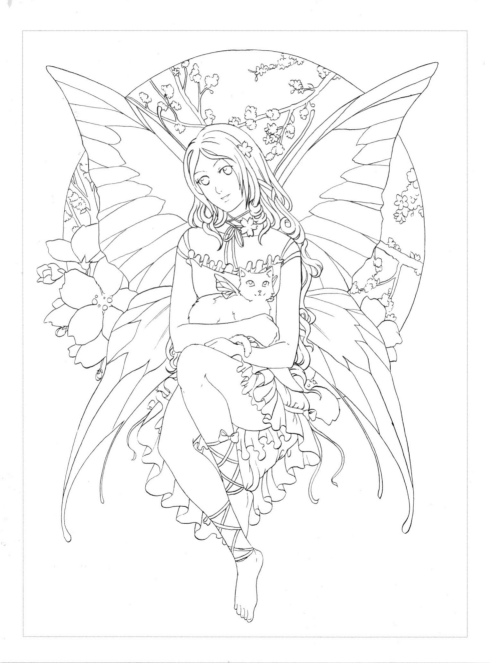

PALETTE
burnt sienna, burnt umber, cobalt blue, Indian red, napthol red, Payne's gray, quinacridone red, sap green, sepia, and yellow ochre

STEP 1 After transferring the fairy to watercolor paper (see "Transferring a Drawing" on page 4), I fill in the dress using a light wash of napthol red and a medium round brush. With this same wash, I dab the flowers on the tree branches and paint the larger blossoms, leaving some areas white for petal highlights. Then I create a slightly darker wash of napthol red and apply a flat wash over the fairy's wings, leaving white along the outer edge of the upper wings. Using a small round brush, I apply a light wash of cobalt blue to fill in the areas between the tree branches. I paint one section at a time, applying my darkest strokes first and then graduating away for soft, cloudlike effects. Then I add a bit of the blue wash to the cat's wings.

STEP 2 Now I create an even darker wash of napthol red and layer washes over the initial wash of the wings, interior of the dress, and the flowers. The variations in the napthol wash values suggest shadows and highlights, creating a sense of form. Then I use a small round brush to fill in the tree branches with a mix of burnt umber and burnt sienna. For the largest flower's center, I use a light wash of yellow ochre. Then I fill in the fairy's hair with burnt sienna and mix this wash with yellow to paint the cat's fur.

STEP 3 I add shadows to the tree branches with a small round brush and a mix of burnt umber and sepia. Then I detail the wings with a dark mix of Indian red and a bit of quinacridone red, outlining the "veins" and creating the dark, symmetrical markings along the outer edges. I also apply this color to the fairy's torso, the ribbon around the skirt, and the flower sepals. To further define the fairy's hair and darken the cat, I apply burnt sienna with a small round brush; then I dilute this color and apply it to the fairy's skin. I add sap green to the fairy's and cat's eyes. To create shadows within the white ruffles of fabric, I use a small round brush and Payne's gray with a touch of cobalt blue.

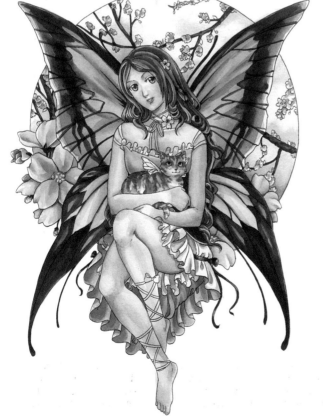

STEP 4 At this point I darken areas of the fairy's skin with a light wash of burnt sienna, giving her subtle form. I also touch a light wash of quinacridone red on her cheeks, fingertips, and toes. I blend these areas so everything is smooth. I add pupils to the fairy and cat using the tip of a small round brush and a mix of sap green and Payne's gray.

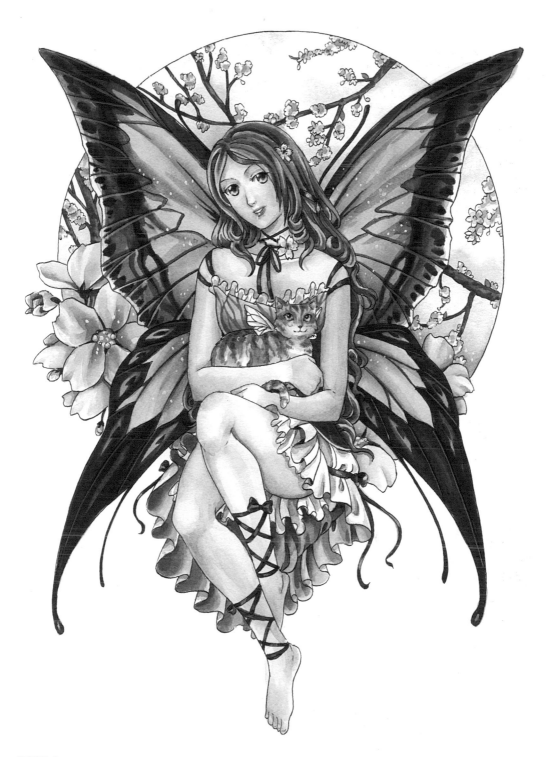

STEP 5 Now I add final touches to the scene to give it a bit more texture and contrast. Using the small round brush, I create more interest within the wings by adding dark red spots along the edges. I apply quinacridone red to the remaining ribbons and then dilute the wash to add thin strokes to the dress. To create more contrast in the fairy's hair and cat's fur, I apply more burnt sienna. Next I create a wash of titanium white and accent some of the wing veins, and then I spatter this white wash onto the wings and in the background for sparkle.

PROJECT 2: CASTLES IN THE SKY

PALETTE
burnt sienna, burnt umber, cobalt blue, Payne's gray, quinacridone red, quinacridone violet, sepia, titanium white, and yellow ochre

STEP 1 After transferring the line drawing to my watercolor paper, I lightly sketch the horizon line and the floating castles in the sky with pencil. Using a size 8 round brush, I wet the paper over the sky and rocky areas. Then I paint a light graduated wash with quinacridone red, thinning it as I move toward the top. While the background is still wet, I apply a flat wash of cobalt blue over the top half of the sky and the areas between the arches.

STEP 2 I paint a flat wash over the stone and arches using a mix of burnt umber, yellow ochre, and quinacridone red. Working wet in wet, I darken areas around the clouds and blend the edges with a clean, wet brush. I use cobalt blue for most of the sky and add a little Payne's gray for darker areas. Using a smaller brush and the quinacridone red wash, I stroke light pink over the floating castles. I add the distant hills using cobalt blue, lightening them as they move into the distance; then I add a little shadow to the arches.

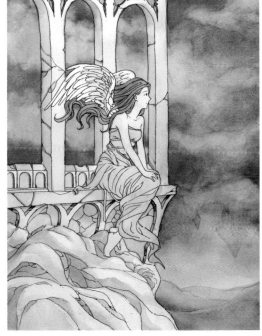

STEP 3 Next I use a light quinacridone red wash for the angel's dress, burnt sienna for her hair, and very pale burnt sienna for her skin. I create a very pale mix of Payne's gray and cobalt blue for the wings, stroking along the inner edges of the wings and blending outward toward the tips. For the shadows within the stone areas, I use the same color I mixed for the stone base (burnt umber, yellow ochre, and quinacridone red) darkened with a bit of cobalt blue. The light source for this painting comes from the sunset at right, so the shadows fall in the other direction. At this point, I keep the shadow areas loose and general.

STEP 4 With a small round brush, I add shadows on the dress using a strong wash of quinacridone red, and I stroke in darker strands of hair using a strong wash of burnt sienna. I add detail and shadows to the floating castles using cobalt blue, keeping in mind the direction of the light source. Then I add more shadows to the rocks and under the arches by mixing even more cobalt blue into the brown base mix. To add interest to the stone surfaces, I vary the intensity of the washes a bit and create the look of old, uneven rock. Remember that none of this shading needs to be perfect, as rocks can be any shape and form.

STEP 5 I outline the feathers on the wings with cobalt blue and Payne's gray, suggesting shadows where the feathers overlap. I paint light cobalt blue along the left side of her dress and blend with a clean, wet brush toward the right. Then I add more shadows to her hair using burnt sienna mixed with a little sepia. I use pale quinacridone red to add a little pink to her cheeks, feet, and fingertips. With a mix of Payne's gray and cobalt blue, I add the darkest areas of shadow to the rocks and use a size 0 brush to create thin cracks. I also use this mix to add dark shadows to the floating castles.

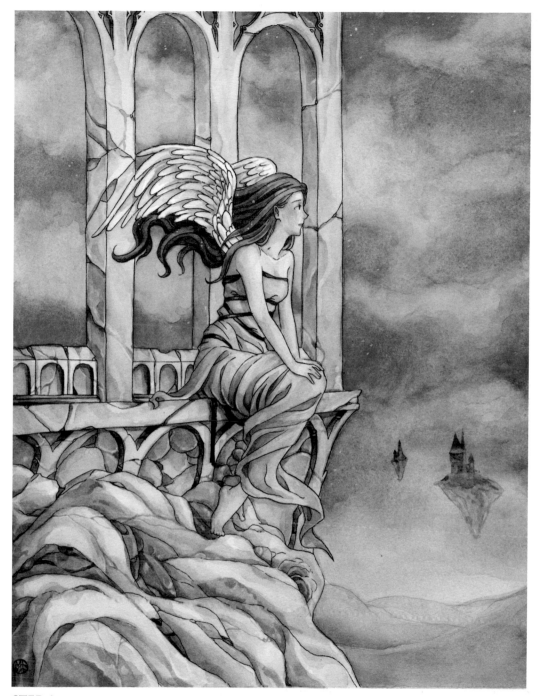

STEP 6 I add darker shadows to the folds on the dress using quinacridone red and a little cobalt blue, and then I color the ribbons with quinacridone violet. I apply a pale pink wash over the rocks beneath the angel and over the archway pillar at right. This serves as reflected color from the sunset and adds a bit of warmth. Using titanium white and a size 0 brush, I add subtle highlights to the rocks, the feathers of the wings, and the undersides of the floating castles. I finish by spattering a few tiny stars in the sky.

PROJECT 3: MUSHROOM FAIRY

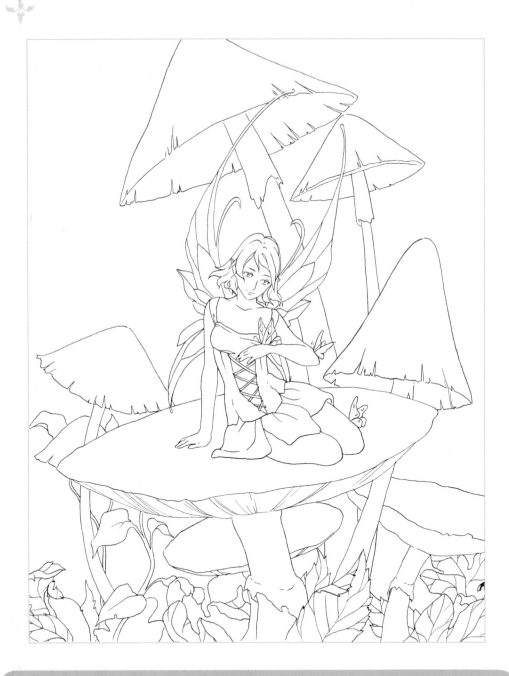

PALETTE
burnt sienna, dioxazine purple, Hooker's green, Payne's gray, phthalo green, quinacridone red, sap green, sepia, titanium white, and yellow ochre

STEP 1 After transferring the line drawing to my watercolor paper, I apply dots of masking fluid on the tops of the flat mushrooms, to the tips of the fairy's wings, and in a few areas of the background. Once this dries, I use a size 8 round brush to add a light layer of yellow ochre over the background and some of the mushroom tops, gradually lightening as I move up. When dry, I apply light sap green around the mushrooms. Next, using a mix of phthalo green and Hooker's green, I paint around the edges of the mushrooms and leaves, blending the outer edges with a clean, wet brush. I also add a little sap green toward the top of the painting. I apply these layers unevenly for a gently mottled look, dabbing spots of paint into the wet washes. I keep in mind that I want some of the original yellow wash to show through in some areas.

STEP 2 I paint the flat mushroom tops using yellow ochre, and I paint the tall, pointed mushrooms using a mix of yellow ochre and burnt sienna, darkening them toward the tops. I add a very pale layer of this color to the stems. For the undersides of the tall mushrooms, I apply a light sepia wash. Then I add a little light sap green and burnt sienna to the leaves on the ground.

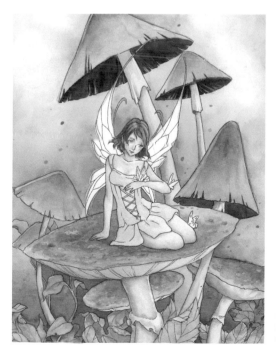

STEP 3 I use burnt sienna to darken the tops of the mushrooms, leaving a small gap for reflected light along the left edge of each and graduating as I move toward the right side. Using a size 2 brush and sepia, I begin painting the gills on the undersides of the tall mushrooms. I stroke from the bottom rim upward and leave small gaps of the lighter background showing through. I shade the undersides and stems of the flat mushrooms with a little phthalo green and sepia. I keep these washes uneven for a natural look. To give the leaves form, I shade with mixes of sap green, Hooker's green, and burnt sienna, and I add little spots of burnt sienna to some of the green leaves. For more contrast, I darken some areas in the background with a mix of phthalo green and Payne's gray. I move on to the fairy and fill in her dress with light yellow ochre and her hair with burnt sienna. Then I apply pale burnt sienna to her skin, touching in quinacridone red on the fingertips, cheeks, and knees.

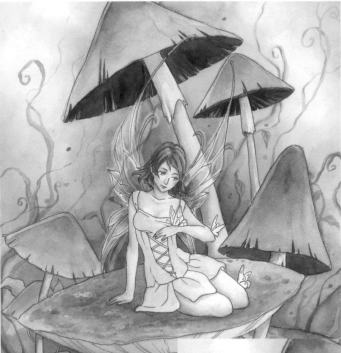

STEP 4 Again I darken background areas with a mix of phthalo green and Hooker's green, leaving the area around the fairy's wings a bit lighter so they don't get lost visually. For some of the darker areas, I add a little dioxazine purple to this mix. With sizes 1 and 2 brushes, I use this darker mix to "draw" twisty tendrils of plant stems in the background. To create a sense of depth, I make some darker and some more transparent. Near the bottom, I outline the shapes of leaves with dark green washes and then blend the paint into the area around them; this helps the leaves "pop" from the scene a bit. Then I paint the fairy's wings using phthalo green with a bit of dioxazine purple, darkening them near her back and making sure to leave white edges around the veins in the wings. I dilute the paint a bit where the wing overlaps the mushroom stem to suggest transparency.

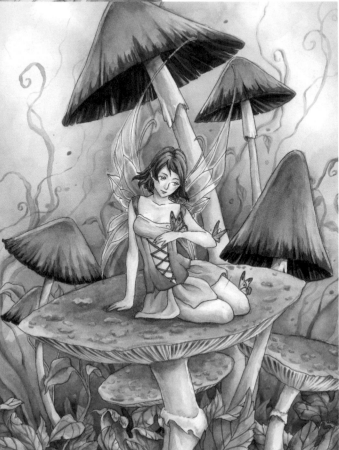

STEP 5 Using sepia, I darken the tops of the tall mushrooms and add long shadows along the stems. I paint the gills on the flat mushrooms with a light mix of sepia and Payne's gray. I add final shading and veins to the leaves using stronger washes of the same colors I used on them initially, adding a little Payne's gray or sepia to darken areas. For the fairy's cast shadow on the mushroom, I paint a light layer of green wash (made up of colors used for the background). Then, using burnt sienna, I stroke shadows along the bottom edges of the mushroom spots. I shade the fairy's dress using equal parts of phthalo green and phthalo blue, and I color the butterflies with quinacridone red, dioxazine purple, and yellow ochre.

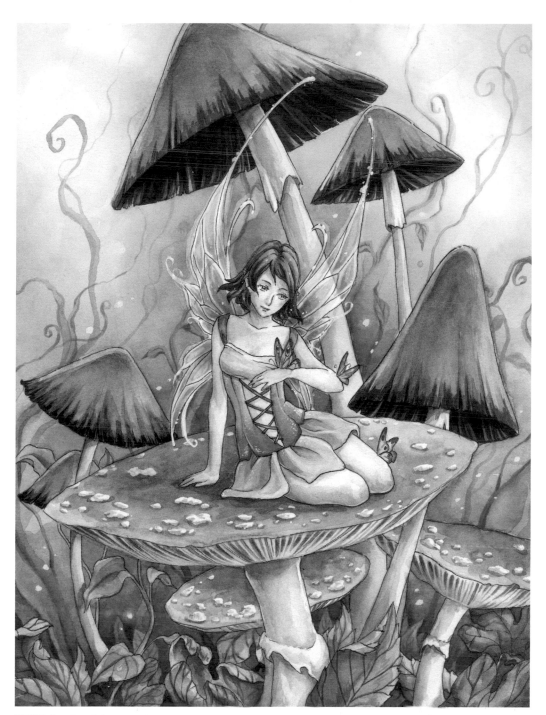

STEP 6 When all the paint is dry, I remove the masking fluid by rubbing it away with my fingers. I add shadows to the white spots on the mushrooms using pale burnt sienna and sepia. I use titanium white and a size 0 brush to add highlights on some of the leaves, mushroom gills, dress, and wings. Still using white, I paint little tendrils curling off the fairy's wings and dot sparkles onto her wings and dress.

PROJECT 4: AUTUMN DRYAD

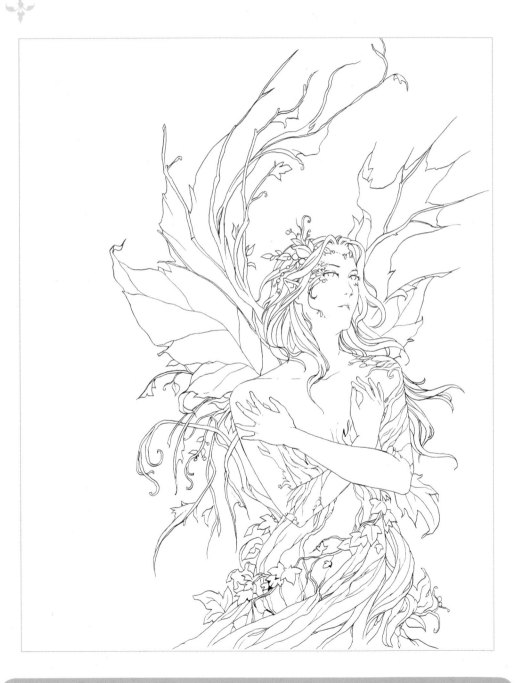

PALETTE

burnt sienna, burnt umber, cadmium orange, quinacridone red, quinacridone violet, sap green, sepia, titanium white, and yellow ochre

STEP 1 I transfer the line drawing to my watercolor paper and then wet the paper around the fairy. Using a light wash of yellow ochre, I cover the background and areas of her wings. As the background will be mottled and rather abstract, I paint loosely and unevenly in this step.

STEP 2 Next I add a very wet layer of darker yellow ochre. I use plenty of water for this step because I want the paint to stay wet for a while. Then I sprinkle table salt on the wet areas and drip a little cadmium orange and burnt sienna in a few of the wet spots. I let the entire painting dry completely before brushing off the salt.

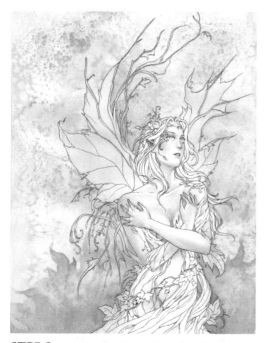

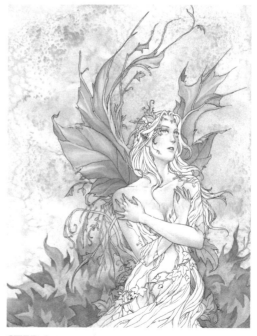

STEP 3 I paint her skin using varying washes of burnt sienna and touches of quinacridone red. With a mix of yellow ochre, burnt sienna, and burnt umber, I paint faint leaf shapes in the background. Then I add more yellow ochre to her wings and the leaves in her hair.

STEP 4 I begin shading her wings and select leaves with cadmium orange and yellow ochre, as I want her wings to resemble autumn leaves. Then I suggest more leaf shapes in the background using yellow ochre, burnt sienna, and burnt umber.

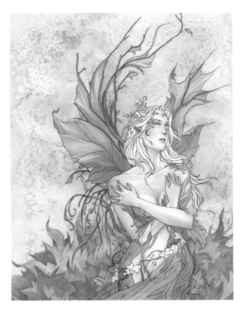

STEP 5 I apply a light layer of burnt umber over most of the tree bark that acts as her dress and the branchlike parts of her wings. This will later serve as the lightest areas of the bark.

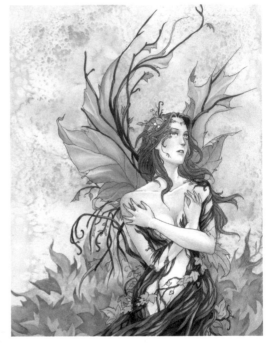

STEP 6 Using long, thin strokes, I paint the texture of the tree bark with a mix of burnt umber and sepia. I use a mix of burnt sienna and burnt umber and do the same for her hair. Then I add a layer of sap green to the ivy leaves, wings, and leaves on her face.

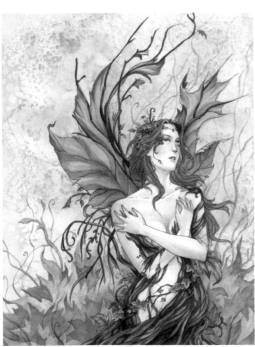

STEP 7 I add a stronger wash of sap green to the centers of the ivy leaves, leaving a lighter edge around each. I touch in sap green along the edges of her wings and over the foliage on her face. Then I add shadows to the rest of the leaves with burnt sienna. For the larger leaves growing off the base of the tree, I add pale layers of green and quinacridone red. I also touch in quinacridone red over her lips and the berries in her hair. Within the background, I use a mix of yellow ochre and burnt umber to add faint branches and curving tendrils behind the leaves.

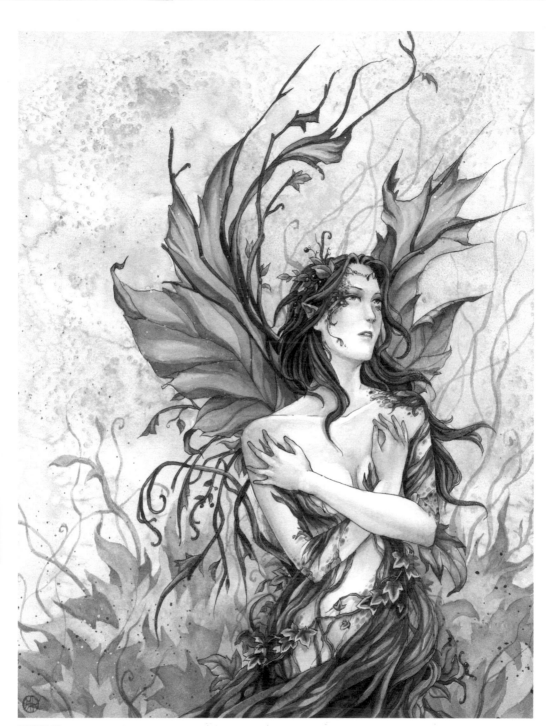

STEP 8 I finish detailing her wings by adding quinacridone red to a few edges. Then I add darker green and red to some of the leaves at the base of the tree. I add shadows to her hair with sepia. I decide that her hands don't look quite finished, so I use a small brush and a mix of burnt sienna and quinacridone violet to darken the fingers and create shadows between the knuckles. Near her elbows and shoulder, I add a few spots of sap green and yellow ochre. I highlight the edges of the ivy leaves with small strokes of titanium white. As a finishing touch, I protect the fairy with a piece of paper and spatter white and burnt sienna over the background.

☩ PROJECT 5: POPPIES FAIRY

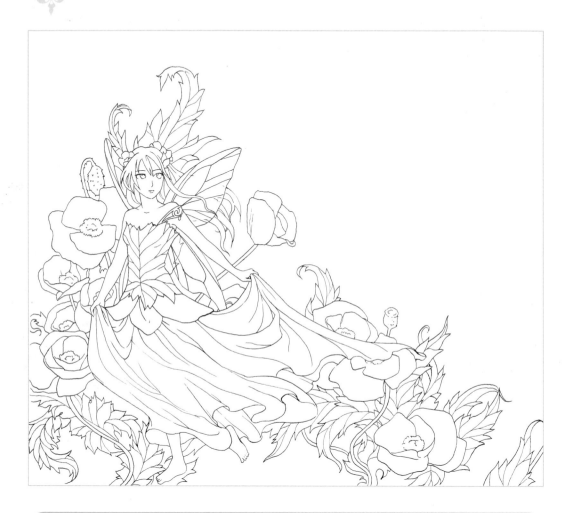

PALETTE
alizarin crimson, burnt sienna, cadmium orange, cadmium red, cadmium yellow, cobalt blue, Hooker's green, phthalo blue, phthalo green, quinacridone red, quinacridone violet, sap green, sepia, titanium white, and yellow ochre

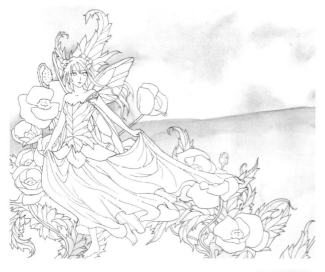

STEP 1 After transferring the line drawing to watercolor paper, I use a brush loaded with clean water to wet everything but the fairy and flowers. Then I apply a mix of cobalt blue and phthalo blue to the sky, dropping clear water on the sky to suggest clouds. I apply a layer of sap green over the hills and foreground leaves, mixing in a bit of phthalo blue for the most distant hill.

STEP 2 I apply another layer of sap green over the hills and foreground leaves, this time including the stem and leaves behind the fairy. Then I mix a dark wash of sap green and apply it to the foreground, working around the shapes of the leaves. Moving on to the fairy's clothing, I apply a light wash of yellow ochre over the leaf bodice, skirt, and wings.

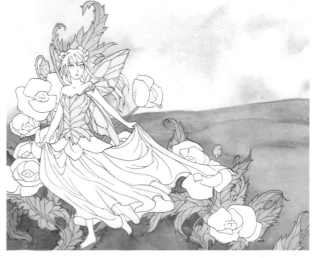

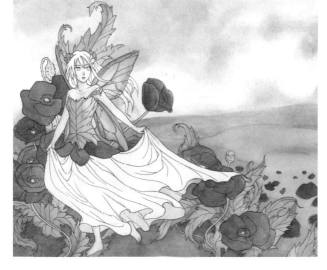

STEP 3 I darken areas of the sky with phthalo blue, and I begin shading the leaves with sap green, Hooker's green, and phthalo green, darkening the center veins and blending outward. I touch in the flower centers with yellow ochre and the petals with cadmium red. I dab on spots of red for flowers in the distance, although these were not drawn in. I outline the fairy wings with cadmium orange and blend toward the center, retaining the yellow glow. I paint pale orange on the underside of the fairy's dress and over the right side of her bodice. I apply sap green to the left side of her bodice and blend toward the right with a clean, wet brush. I layer a bit of cadmium yellow and orange on the flowers and leaves in her hair, and then I use cadmium red to fill in the upper part of her skirt. I also begin painting her skin with pale burnt sienna.

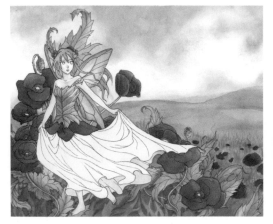

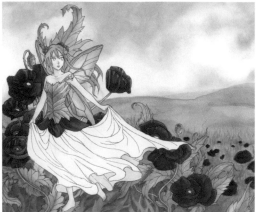

STEP 4 I darken the sky with a little more blue and fill in her hair with a layer of burnt sienna. I also add another layer of cadmium red to the flower petals. Using sap green, I suggest transparent leaves around the distant flowers and begin shading leaves in the foreground. I use the negative painting technique and a wash of sap green and Hooker's green to suggest grass. Then I sharpen and darken the distant hill, leaving a lighter area in the center.

STEP 5 I shade the poppies and red petals of her skirt with one layer of alizarin crimson, leaving lighter areas to suggest a thin, gently rippled surface. Then I apply a second layer of shading to the petals with a mix of alizarin crimson and a bit of quinacridone violet. (For demonstration purposes, the flowers to the right of the fairy show only the first layer of shading, and those on the left have been completed with two layers. Note the form brought out by the second layer.)

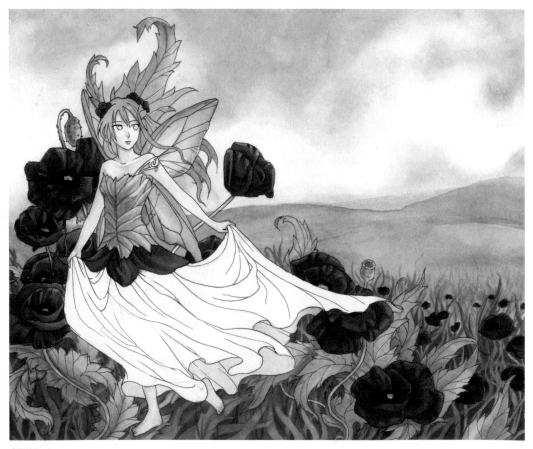

STEP 6 I create the flower centers using a size 0 brush and small dots of sepia. Then I continue painting the areas between the leaves and grass, pushing the shadows by adding layers of cobalt blue. Next I add thin, dark green blades of grass using Hooker's green and phthalo blue.

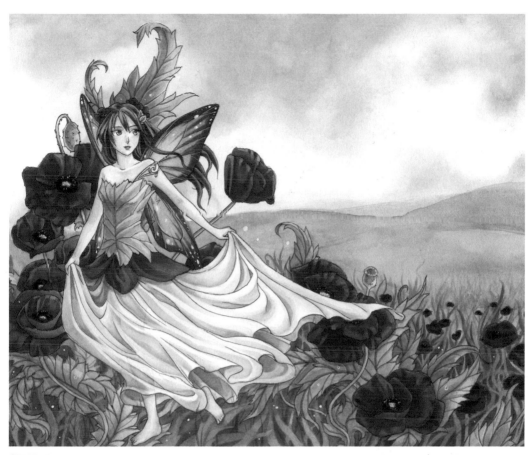

STEP 7 I finish the details on the leaves by "drawing" the veins with Hooker's green and the tip of a fine brush. I mix cadmium yellow, sap green, and titanium white and apply highlights to the sunlit sides of the leaves. Then I move on to the fairy's skirt, adding folds and shadows with varying washes of yellow ochre and cadmium orange. I apply a light layer of sap green over some folds at left to suggest reflected light from the greenery. I create the pattern on the wings using cadmium red, and I finish shading her skin with burnt sienna and quinacridone red. I shade the hair with strokes of burnt sienna and sepia. For her eyes, I apply a mix of yellow ochre, burnt sienna, and sepia. To finish, I use titanium white to highlight the flower centers, complete the wing pattern, and add sparkle to the foreground.

FACE DETAIL

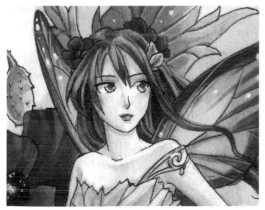

FLOWER DETAIL

PROJECT 6: WISTERIA FAIRY

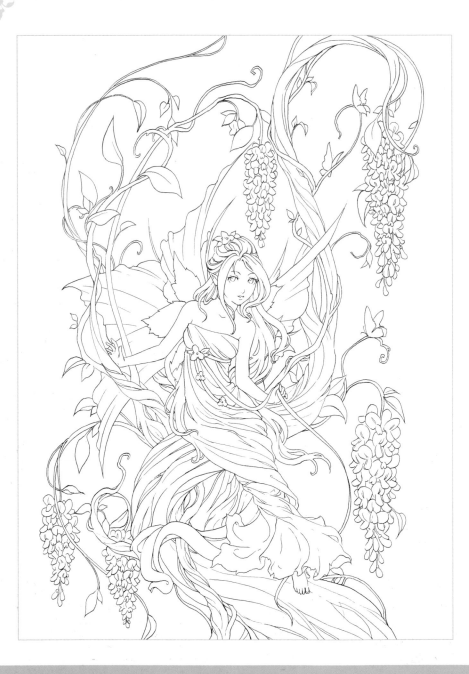

PALETTE

burnt sienna, burnt umber, cadmium yellow, cobalt blue, dioxazine purple, Hooker's green, Payne's gray, phthalo blue, quinacridone red, sap green, sepia, and titanium white

STEP 1 I transfer the line drawing to watercolor paper and then wet most of the background with clean water and a brush. Then I use a size 8 brush and a light wash of phthalo blue to paint around the fairy. I allow the blue to bleed over parts of the branches, as this can later serve as reflected light. For subtle variation, I touch a bit of dioxazine purple into the edges and corners.

STEP 2 With a size 2 brush, I paint a light layer of purple over the flowers, dress, and wings. I apply sap green to all the leaves, and I fill in the butterflies with purple, cadmium yellow, and phthalo blue. Then I paint a very pale layer of burnt sienna over her skin.

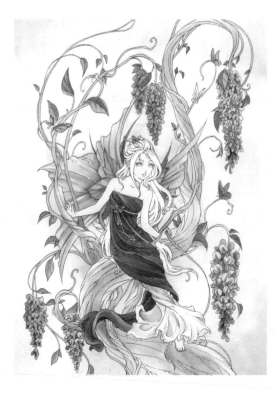

STEP 3 Using a stronger wash of sap green, I give the leaves form by darkening one side and suggesting veins. Then I create a stronger wash of dioxazine purple and add folds and shadows to the dress. I also apply this purple to the flowers, reserving the darkest values for the gaps between flowers, and to her rippled wings. Because the wings are darkest near the center, I blend the color with clear water as I move toward the outer edges. Then I dilute the wash a bit and add light purple shadows to the white fabric of her dress. For the base coat of the tree branches, I use a light layer of burnt umber and leave some of the outer edges blue. I also add another layer of color to the interior of each butterfly, and I paint the fairy's eyes with phthalo blue.

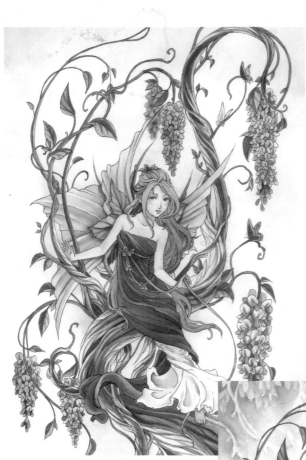

STEP 4 I pump up the contrast by adding darker shadows to the dress, flowers, and wings. I also darken some of the veins on the leaves with Hooker's green. For the darkest shadows on her dress, I add some cobalt blue to the purple wash from step 3. I begin painting her hair with a layer of Payne's gray, and I finish shading her skin with burnt sienna and touches of quinacridone red for her fingers, cheeks, and toes. On the branches, I begin creating the bark texture with long, thin strokes and mixes of burnt umber and sepia. I mix in a little Payne's gray for the darkest areas.

STEP 5 In this step, I add interest to the background by suggesting flowers and vines. Using mostly phthalo blue with a little cobalt blue and touches of dioxazine purple, I "outline" a flower, leaf, or stem shape and then blend the outer edges with clean water. In a few areas, I strengthen this wash by dabbing in more blue while the paper is still wet. Because I didn't initially draw these shapes, I place them so they work effectively within the composition of the entire piece.

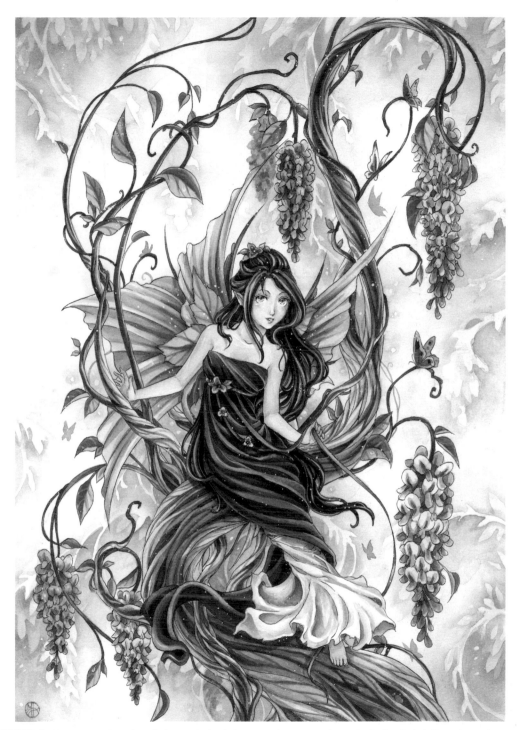

STEP 6 I finish adding the darkest shadows to the fairy's dress using dioxazine purple mixed with a bit of cobalt blue and Payne's gray. On the white fabric, I shade with mostly purple and touches of cobalt blue. I paint a light layer of cobalt blue over the flower bunches farthest from the viewer, and I apply more light phthalo blue over the outer edges of the branches. I add a few darker shadows to the tree branches with sepia. I finish her hair using Payne's gray and add a few streaking highlights with titanium white. Using cobalt blue and purple, I add some details to the butterflies and suggest a few new distant butterflies in the background. I paint water drops on a few leaves with white and outline the flowers on her dress. To finish, I lightly spatter white over most of the painting.

PROJECT 7: ENCHANTED FOREST

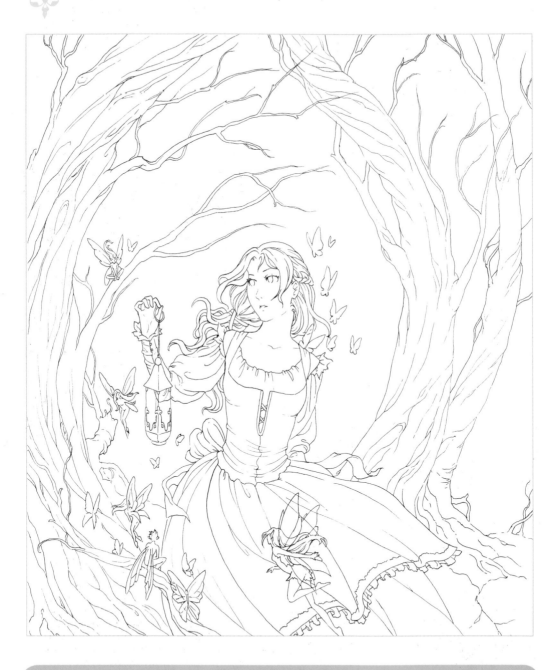

PALETTE

burnt sienna, burnt umber, cadmium yellow, cobalt blue, Payne's gray, quinacridone red, quinacridone violet, sepia, titanium white, and yellow ochre

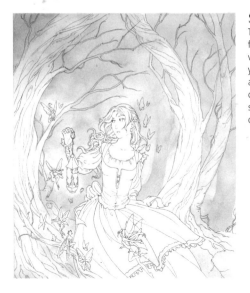

STEP 1 I begin by transferring the line drawing to watercolor paper. Then I wet the paper in the background, working around the girl and the fairies. I paint the areas between the trees using a size 8 round brush and a very pale mix of cadmium yellow and quinacridone red. Then, using cadmium yellow and a smaller size 2 brush, I wash over the lamp and create a glow around the fairies, leaving their actual figures white. With a light wash of cobalt blue, I paint over much of the sky and trunks, and I suggest faint shapes of trees behind the drawn foreground trees. I also faintly cover some of the foreground and the girl's apron with light cobalt blue shadows.

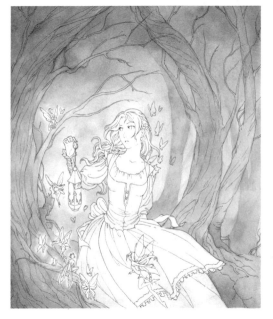

STEP 2 I paint the foreground trees with a mix of burnt umber and burnt sienna, avoiding the smaller branches at this point. I add another layer of cobalt blue and purple to the sky, distant trees, and foreground; then I paint the distant tree branch to the left of the fairies with light dioxazine purple and cobalt blue. As I continue to build up the blues, I keep in mind that I want to create the impression of a glow emanating from the lamp and fairies. Graduating to darker shades of blue as I move away from the glow will create this effect. Next I add a pale layer of quinacridone red and cadmium yellow to the girl's dress.

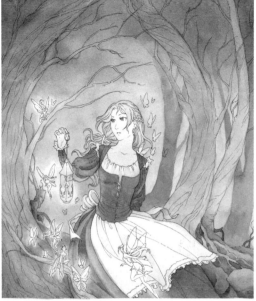

STEP 3 Now I paint the girl's dress with a darker mix of quinacridone red, burnt sienna, and a little quinacridone violet. I carefully pick out the shadows, considering the lamp and fairies as the light source. I also begin adding more shadows to the white areas of her dress with a little cobalt blue and Payne's gray. Moving on to the girl, I apply a light layer of burnt sienna warmed with a bit of cadmium yellow over her skin. I use a stronger version of this wash for her hair and burnt umber for her eyes. In the center of the lamp I create a circle of yellow ochre (leaving the center of the circle white) using a size 2 brush and blending the paint toward the outer edges of the lamp. I darken the upper part of the sky with more cobalt blue and Payne's gray; then I use this same color to darken the trees in the background and add shadows to the base of the trees and the rocks.

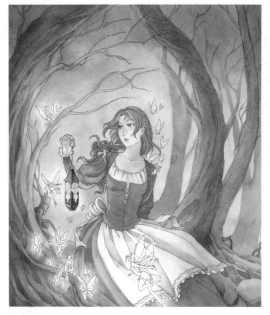

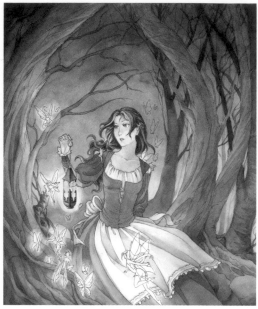

STEP 4 Using a size 2 brush, I add shadows and texture to the tree trunks with a mix of burnt umber and sepia. I apply more shadows to the folds on her apron and the top of her dress with cobalt blue and Payne's gray, being careful to paint around the fairy. With burnt sienna and a touch of quinacridone violet, I add shadows to the girl's skin. I enrich her hair with another layer of burnt sienna, leaving areas facing the lamp lighter. I create the metal of the lamp with Payne's gray, working with the glow of the fairies.

STEP 5 Now I darken the upper part of the sky again with a glaze of cobalt blue and Payne's gray. I also enlist this color to add a little texture to the distant blue-purple tree at left. I build up shadows on the trees using burnt umber, sepia, and a bit of Payne's gray. To create shadows and darker strands within the girl's hair, I use a small brush and a mix of burnt sienna and sepia. Then I create a halo of light around the fairies by encircling each with a wash of the lighter background blue.

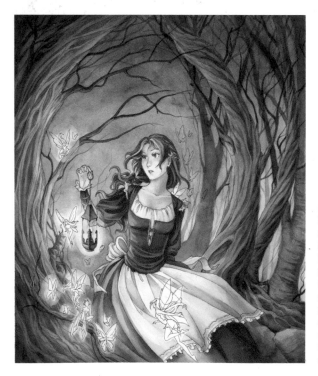

STEP 6 I use a light layer of a mix of Payne's gray and cobalt blue to add more trees and branches in the background. I also use this color to create more shadows on her apron and to define areas within the foreground. I stroke more shadows into the tree bark by adding a little more Payne's gray to the burnt umber and sepia mix, and I use long, thin strokes to create the rippled, twisting texture. I also use this color to darken the smaller branches. For the girl's dress, I mix quinacridone red and quinacridone violet. I add a little cobalt blue and dioxazine purple to this mix to create the folds and shadows. Then I subtly darken the shadows on her skin with burnt sienna and quinacridone violet, adding a bit of cobalt blue for the darkest areas.

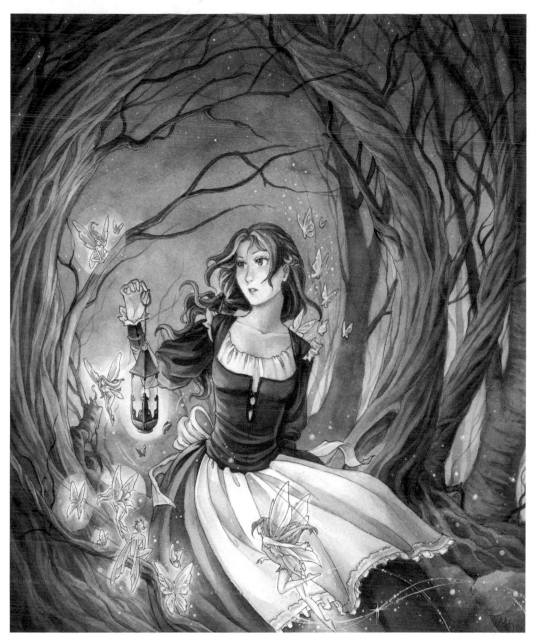

STEP 7 With the background in place, I move on to the fairies. I use a size 1 brush to shade the fairies and butterflies with a mix of yellow ochre and burnt sienna, leaving the edges of the wings white. Then I mix this color with titanium white and add highlights to a few areas, such as the branches near the fairies and the area of the girl's arm that is closest to the lamp. I also use this color for most of the sparkles in the background and stars in the sky, and I switch to pure white to create the lightest sparkles. For the fairy nearest the viewer, I stroke thin lines of white to suggest her path of flight. Because the butterflies over the girl's shoulder are influenced by the initial blue wash, I decide to lighten them using a mix yellow ochre and white. I add more white to the mix and build up layers on the lamp lit areas of the butterflies.

❖ PROJECT 8: WINTER FAIRY

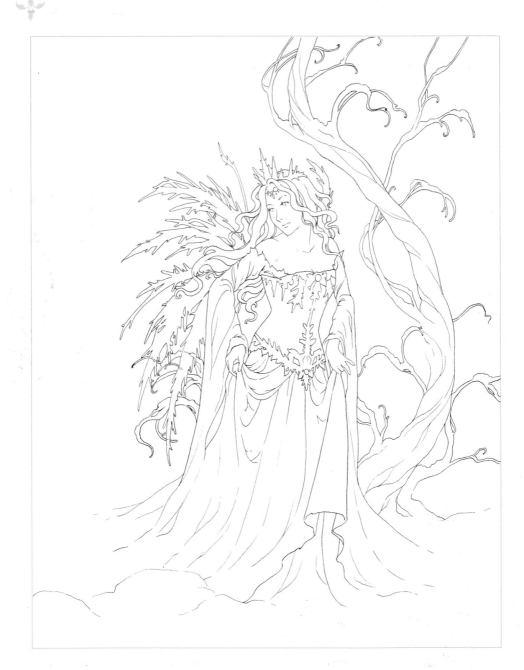

PALETTE

burnt sienna, cobalt blue, Payne's gray, phthalo blue, quinacridone red, and titanium white

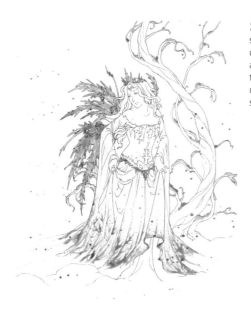

STEP 1 First I transfer the image to my watercolor paper. Then I use a size 0 chisel soft-tipped rubber brush (or colour shaper) to apply masking fluid over the snowflake-inspired designs along the bottom of the fairy's dress. I also cover the wings, crown, design around the waist, and snow resting on the tree branches, working carefully within the lines of my drawing. Then, using the same brush, I spatter masking fluid over the background for falling snow.

STEP 2 After the masking fluid dries, I wet the background and apply two light layers of a mix of cobalt blue and phthalo blue. I also apply a bit on the underside of her dress. I don't worry about the tree because I will darken it later. I allow these layers to dry and then wash a mix of cobalt blue with a little Payne's gray over the lower half of the sky, blending the paint upward with clean water.

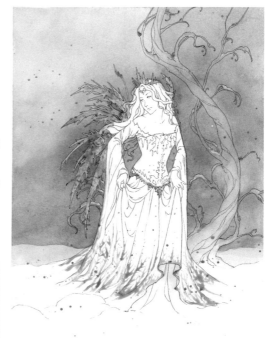

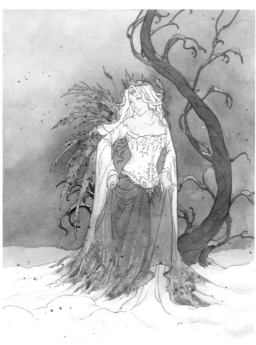

STEP 3 Using a size 4 round brush, I paint the tree with a medium-dark wash of Payne's gray. Then I use cobalt blue to add shadows along the mounds of snow, blending the edges for a soft look. Next I paint her dress with mix of cobalt blue and Payne's gray, and I add pale cobalt blue to her bodice and sleeves. Then I create a pale mix of burnt sienna with a bit of quinacridone red and wash it over her skin.

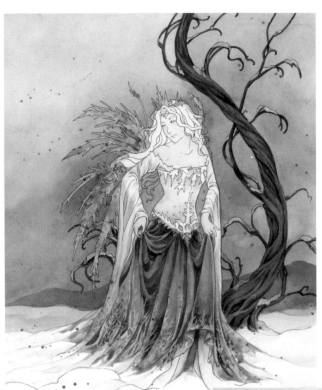

STEP 4 With a size 2 round brush, I suggest hills in the distance with a wash of cobalt blue and Payne's gray. I add shadows to the hills in the middle ground with cobalt blue, blending the edges. I create shadows and folds in the skirt using cobalt blue and Payne's gray. For the lighter sleeves and bodice, I shade with cobalt blue and carefully work around the snowflake designs on the bodice. Next I paint twisting shadows on the tree with Payne's gray, following the lines in the drawing.

STEP 5 Once the paint is dry, I rub off all the masking fluid with my thumb. I use light cobalt blue and a size 2 brush to add subtle shadows in the snow on the tree branches, and I stroke shadows into white areas of her dress and the snow on the ground. Next I paint cobalt blue on sections of her wings, leaving white in areas to give the impression of ice crystals or frost. I shade her skin with more burnt sienna, applying pale quinacridone red on her cheeks and fingertips. Then I mix in a tiny bit of cobalt blue and create a shadow under her chin. Using a wash of Payne's gray, I apply a layer over her hair and then add little trees in the far background. These don't need to be detailed at all—I loosely suggest their shapes. Then I paint a few thin, wispy branches directly behind the fairy. To add interest in the foreground, I add a few evergreen branches using Payne's gray and the short strokes of a size 1 or 2 brush.

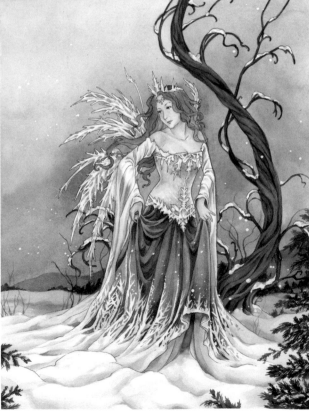

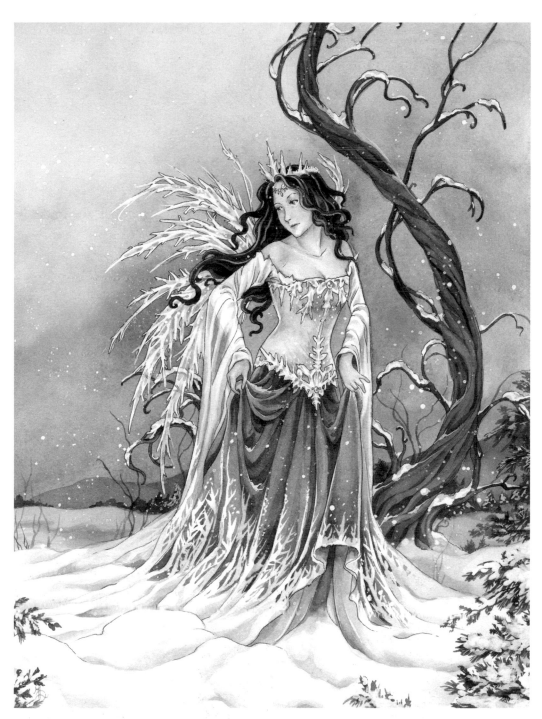

STEP 6 I add darker strands of hair using darker washes of Payne's gray. Then I use titanium white to add more snow on the tree branches and enhance folds in her dress. I touch up and extend the edges of the wings and crown, and I create highlights on the dress. Next I dab several layers of white paint on the pine branches in the foreground to suggest snow. I also paint short, thin strokes for snow-covered pine needles in the distance. To finish, I spatter white over the entire painting to create falling snowflakes.

PROJECT 9: MERMAID

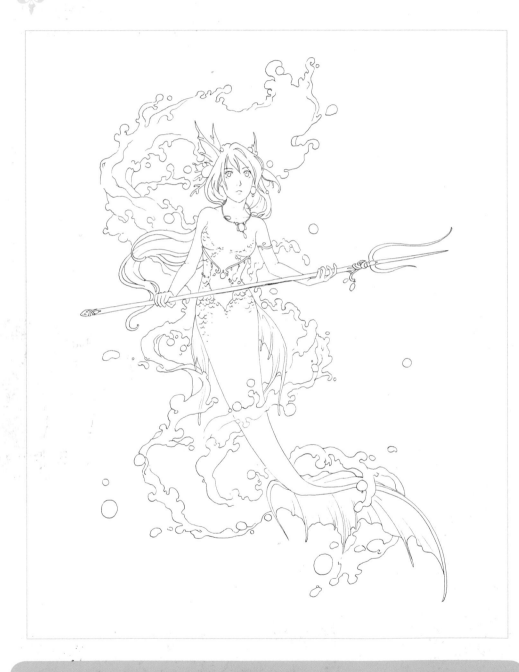

PALETTE

burnt sienna, cadmium orange, cadmium yellow, cobalt blue, phthalo blue, phthalo green, sap green, sepia, titanium white, and yellow ochre

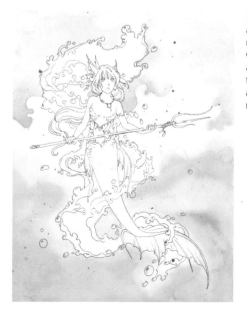

STEP 1 After transferring the line drawing to watercolor paper, I use a size 0 chisel soft tipped rubber brush (or colour shaper) to spatter some masking fluid over the background. Then I use the tip to mask spots on the water droplets and along the edges of the wave behind the mermaid. These areas will later serve as white highlights. I use phthalo blue and a size 4 brush to paint the sky above the outline of the wave, graduating to a thinner wash as I move up. Then I wet the area that will be underwater and fill it in with a mix of phthalo blue and phthalo green, working around the mermaid's tail.

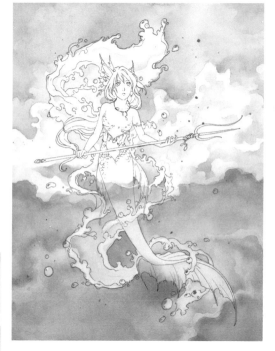

STEP 2 With a size 4 brush, I use phthalo blue to create stronger outlines of clouds in the sky, blending the edges into the background. With a mix of phthalo blue and phthalo green, I paint an uneven edge for the surface of the water and darken the area below this, building up subtle underwater ripples and curls. Then I use pale phthalo blue to add shape to the waves above the water's surface. I "draw" an outline beneath the white edges of the waves and blend the lower areas into the wave.

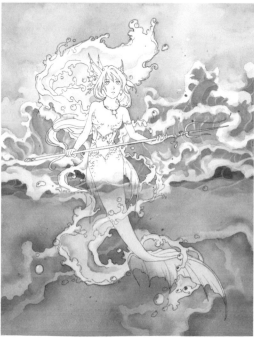

STEP 3 Using a size 4 brush, I continue adding more layers of phthalo blue and phthalo green over the lower half, varying the intensity of the wash and defining the underwater ripples. For the surface of the water, I use the same color and a size 2 brush to create parallelogram shapes, forming the impression of small peaks. Then I darken the area under the white-edged waves using phthalo blue and cobalt blue, leaving light lines to suggest the curvature of the waves.

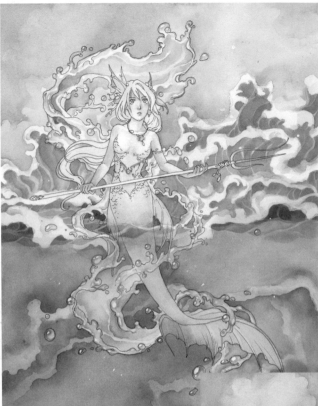

STEP 4 With a size 2 brush, I paint the mermaid's skin using pale burnt sienna. I apply a light layer of cadmium yellow over her tail and bodice, keeping it a little darker on the sides of her hips to suggest form. I paint a light layer of yellow ochre over her hair and fill in her eyes and head fins with a mix of pale cadmium yellow and sap green. Then I apply a layer of sap green over most of the section of her tail that is underwater. I paint a light layer of cadmium orange on the upper side of the tail fin, and I use sap green on the underside. Next I paint the water droplets, the rounded edges of the splashing water, and the mermaid's jewels. For each round shape, I begin by painting around the highlight (the area masked out in step 1) and then blend this toward the opposite edge. Then I add more definition to the upper part of the wave behind her head using phthalo blue and cobalt blue.

STEP 5 I continue darkening the waves with phthalo blue until I am satisfied with the contrast. I use a mix of phthalo blue and phthalo green to enhance the darkest areas of the underwater section and the shapes on the surface of the water. Then I increase the contrast in the sky by adding darker areas between clouds with phthalo blue. Using a mix of sap green and phthalo green, I add darker accents to the mermaid's hair, head ornaments, and fins. I darken the outer edges of the mermaid's tail using darker washes of the same colors previously used. I allow this to dry and then outline the tail scales using a size 2 brush and scooping brushstrokes. I use yellow and orange for the scales above water and phthalo green for the scales underwater. Then I use phthalo blue and sap green to darken the grooves of the fins, adding form and texture. For the mermaid's staff, I use a size 2 brush and yellow ochre to line the outer edges, leaving a thin white section in the center.

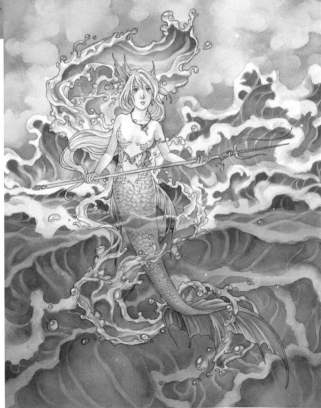

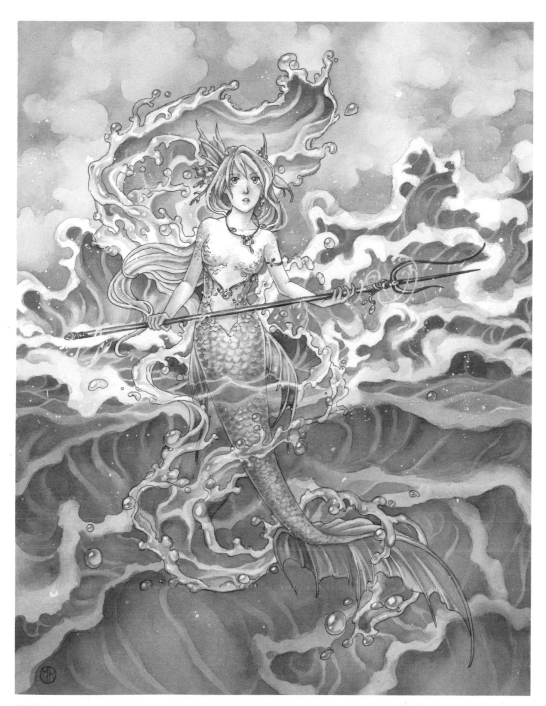

STEP 6 I add wash of phthalo blue over some of the underwater sections to darken and influence the hue. I shade her hair with a mix of yellow ochre and phthalo blue. I use very pale phthalo blue to bring out reflected light on the undersides of her arms, hands, and chin. I use quinacridone red to blush her cheeks a bit and to color some of her hair and necklace ornaments. I apply darker shadows along her staff with a mix of yellow ochre, burnt sienna, and a little sepia. I add dark shadows to the outer edges of the mermaid's tail and bodice (the sections above water) using cadmium yellow and cadmium orange. For underwater section, I create shadows along the edges by *stippling* (or dotting on) phthalo green to suggest form. I also stipple scales onto her upper arms using cadmium orange. Next I use titanium white to highlight scales along the center of her tail, and I add thin swirls and falling water droplets around the end of her staff. For a final touch, I spatter white over the splashing waves in the background and the sky.

PROJECT 10: CELTIC FAIRY

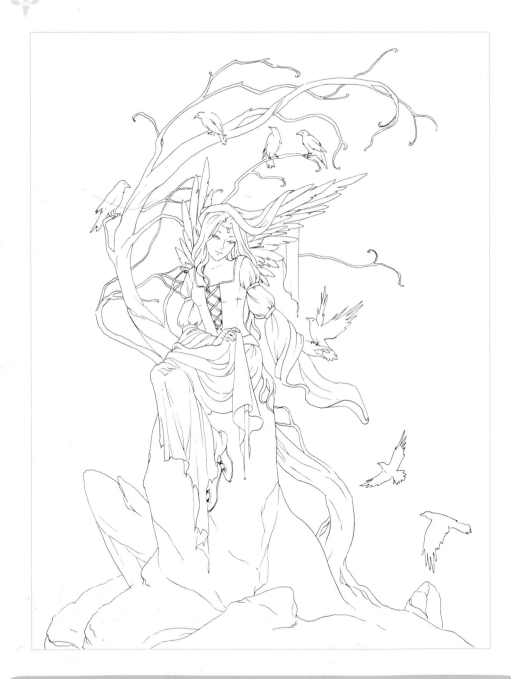

PALETTE
burnt sienna, burnt umber, cobalt blue, Hooker's green, lamp black, Payne's gray, phthalo blue, sap green, and titanium white

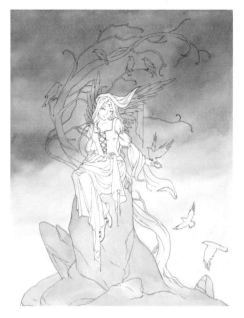

STEP 1 I transfer the line drawing to watercolor paper and wet everything but the lower ground and figure. I use a large ³/₄-inch oval mop brush loaded with a mix of cobalt blue, phthalo blue, and Payne's gray to paint a graduated wash over the sky, darkening toward the top. Because this will be a stormy sky, I keep my strokes loose. I apply a flat wash of Payne's gray over the stones and use pale sap green for the grass.

STEP 2 I darken areas of the sky using a size 8 brush and a mix of cobalt blue, phthalo blue, and Payne's gray, blending the edges with clean water. For the background hills, I apply flat washes of Hooker's green and a bit of cobalt blue. Then I create the stone texture by applying a heavy wash of Payne's gray and then dabbing darker spots of Payne's gray into the wet area. Next I spatter clean water over this wet area and allow everything to dry.

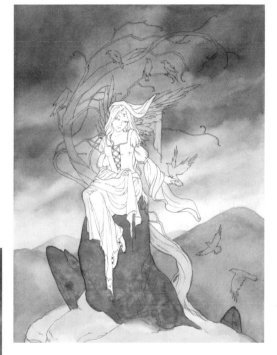

STEP 3 I continue darkening the sky with cobalt blue, phthalo blue, and Payne's gray. I give form to the rocks by adding shadows with a mix of Payne's gray and a little cobalt blue. Then I wet the grass area and apply a mix of burnt umber, sap green, and cobalt blue, using more burnt umber in the areas closest to the rocks. Next I use mix of Payne's gray and cobalt blue to create additional rows of hills, darkening those nearest the bottom to create atmospheric perspective. I outline the hill shapes with mixes of sap green and cobalt blue, blending all the edges downward and into the wash. Next, in the far distance, I use cobalt blue with a little Payne's gray to suggest mountain peaks; then I blend the lower edges into the sky to give the appearance that they are fading into the mist.

STEP 4 To add little trees on the distant hills, I use cobalt blue and Payne's gray. I use this same mix to cover the foreground tree, birds, and fairy's wings. I apply a second layer in the center of the trunk. For darker shadows on the rocks I apply a mix of Payne's gray and cobalt blue. Then I use the tip of a size 2 brush with a mix of cobalt blue and sap green to create short strokes for grass. I apply some of these strokes wet in wet to give the impression of grass rather than individual blades. For the angel's skin, I use a cool mix of burnt sienna and cobalt blue. I use a flat wash of phthalo blue and Payne's gray for the dress, and I use a diluted version of this wash on the bodice, shoes, and shadows on the white cloth. Then I apply a flat wash of Payne's gray over her hair.

STEP 5 Using a size 2 brush, I darken the shoes and shadows on the rocks and tree with Payne's gray. I add shadows and folds in her dress with mix of phthalo blue and Payne's gray. To create dark shadows in her hair and define individual feathers on her wings, I use a strong wash of Payne's gray. With an even darker wash of Payne's gray, I fill in the birds, leaving light areas along the wing tips. I also darken areas of the grass with cobalt blue and sap green.

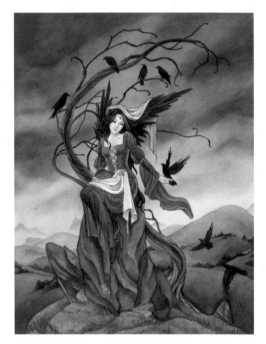

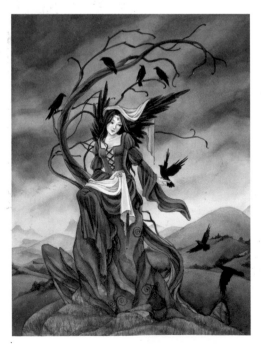

STEP 6 I continue to strengthen shadows on the tree with long, thin strokes of Payne's gray. I add the darkest shadows to the crows using Payne's gray mixed with a little lamp black. I use this same wash to darken the folds in her dress and fill in the laces and arm bands. I add shadows on her shoes directly under the edge of her skirt with Payne's gray. Using a very pale cobalt blue, I add more shadows to her skin under the hair and chin. Next, using Payne's gray and a size 1 brush, I "draw" several spiral designs on the rocks. Then I use a size 1 rigger brush with a mix of cobalt blue and sap green to add a few longer blades of grass.

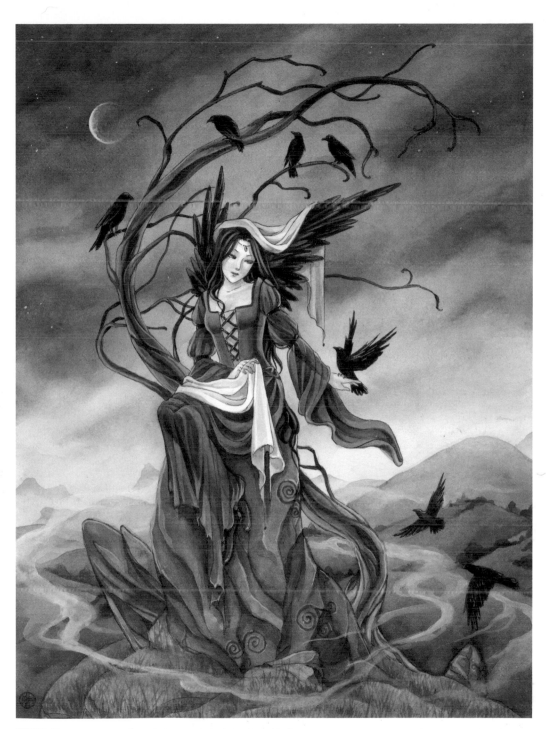

STEP 7 Using a wash of titanium white, I add small highlights to the feathers on the fairy's wings and the birds' wings. I also highlight edges of the rocks, the outer sides of the tree, the folds on her dress, and the light streaks in her hair. Next I dot on white for stars in the sky, and I stroke a crescent for the moon, making the outer edge opaque and blending toward the inner edge. Finally, using a size 2 brush and a white wash, I paint several layers of mist encircling the rocks and hill in the foreground. I blend the wider sections of this into the background using clear water.

PROJECT 11: FAIRY TALE PRINCESS

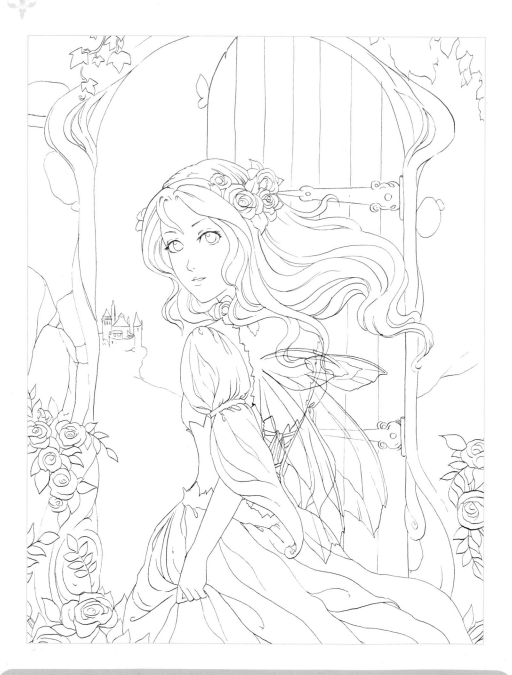

PALETTE

burnt sienna, burnt umber, cadmium yellow, cobalt blue, dioxazine purple, Hooker's green, Payne's gray, phthalo blue, phthalo green, quinacridone red, sap green, titanium white, and yellow ochre

STEP 1 After transferring the line drawing to watercolor paper, I wet the door and the sky with a size 8 round brush and clean water. Then I the outline the clouds near the horizon with phthalo blue and touch in the rest of the sky wet in wet. Next I apply a variegated wash moving from blue-green (phthalo blue and phthalo green) on the castle moving down to sap green. I apply a pale wash of phthalo green over the door and sap green over the leaves.

STEP 2 With a mix of Payne's gray and burnt umber, I loosely paint the stone archway. While still wet, I drop in darker Payne's gray beneath the leaves and above the rim of the door. I re-wet the sky and add more phthalo blue, pushing around the pigment to form clouds. Then I add definition to the castle with phthalo blue and phthalo green, and I darken the door with the same. I also strengthen the ground and leaves with another layer of sap green.

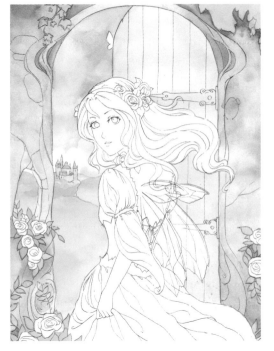

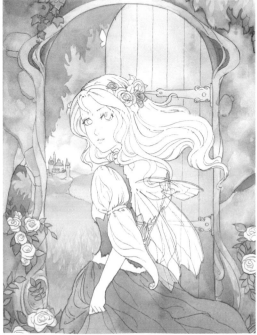

STEP 3 Next I paint a few flowers in the girl's hair and her dress with phthalo blue, mixing in dioxazine purple toward the bottom right. I use a diluted mix of the same color for the areas covered by the wings. Using a very pale wash of cadmium yellow, I cover the roses in the foreground and a few in her hair. I darken the leaves with a mix of sap and phthalo green. I also add more texture to the stone with a varying wash of Payne's gray, and I wash this over the right side of the door. For the foliage hanging behind the door, I use a flat wash of a sap green and cobalt blue mix.

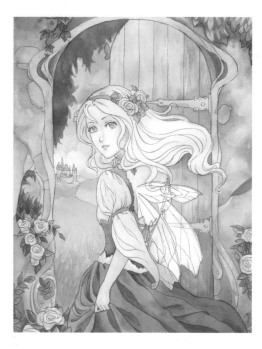

STEP 4 I apply burnt sienna over her skin, touching in quinacridone red for darker areas. I use a pale wash of phthalo blue and dioxazine purple for her sleeves and waistband, darkening the color as I move toward her back. I add shadows and folds in the skirt with a strong wash of phthalo blue and dioxazine purple. I use sap green for her eyes, working around the highlights. I add a bit of Payne's gray and Hooker's green to the wash and detail the foreground. Using phthalo green and cobalt blue, I darken and define the hanging foliage. I apply a wash of cadmium yellow and yellow ochre to her hair, and then I use this wash to shade the roses. Using a mix of phthalo blue and Payne's gray, I texture the door with rough, vertical strokes.

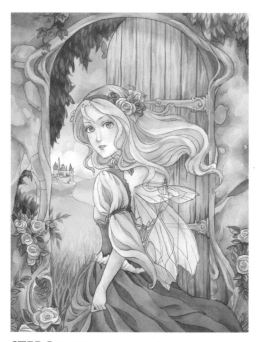

STEP 5 I add shadows to the gaps between her hair strands with yellow ochre plus a little burnt sienna; then I give her face and arm more form with light burnt sienna and a little quinacridone red. Next I add darker shadows in the folds of the sleeves with light phthalo blue and a little purple. I paint the wings with a graduated wash of phthalo blue and phthalo green. Then I finish adding shape to the hanging leaves with a mix of phthalo blue and Payne's gray. I use a rigger brush to paint blades of grass with sap green, getting darker toward the foreground. To give the door a wood grain texture, I use a mix of phthalo blue and Payne's gray to paint short, uneven streaks vertically with a size 2 brush. I use sap green over yellow ochre for the door hinges, using more green in the darker areas. Then I paint darker pits and cracks in the stone wall with Payne's gray plus a little cobalt blue. I make the stones stand out by painting around them with dark gray.

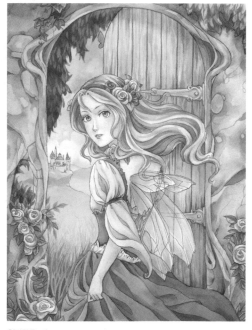

STEP 6 Next I make some strands of hair darker using yellow ochre plus burnt sienna. I use the same color to darken areas between the petals on the roses. Using phthalo blue and purple, I add a simple lace pattern on the edges of her dress and color the butterfly on the door. To give the wings form, I use phthalo blue with phthalo green to paint between the veins, leaving a thin white gap at the edges. Finally, I add a few darker cracks in the stone wall.

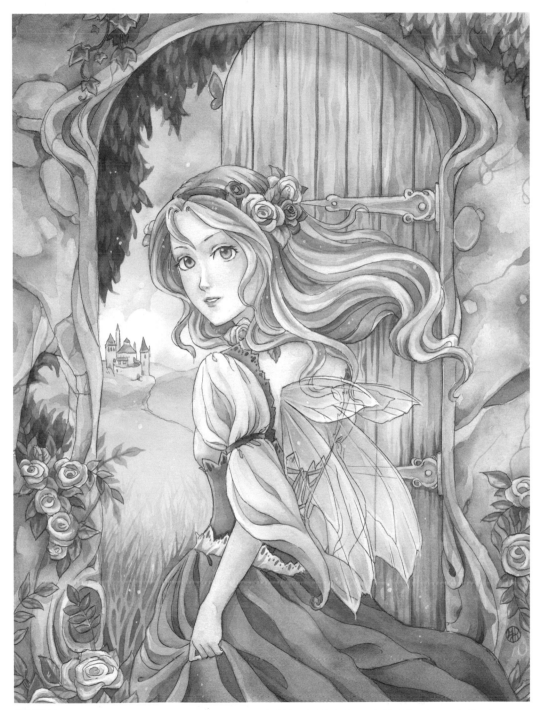

STEP 7 I create a bit more contrast within the skirt, darkening the folds with phthalo blue and a bit of dioxazine purple. Then I use titanium white to place a few sparkles on the painting, focusing on the wings and hair. To finish, I add highlights along the lower edges of the wings.

PROJECT 12: FAIRY ROYALTY

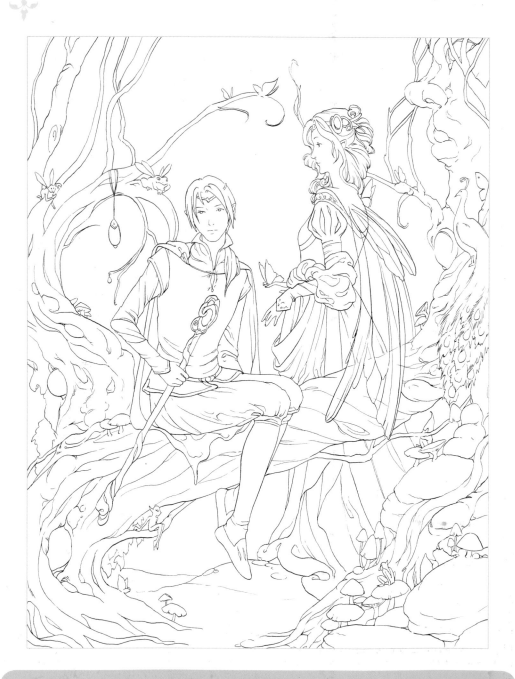

PALETTE

burnt sienna, burnt umber, cobalt blue, dioxazine purple, Payne's gray, phthalo blue, phthalo green, quinacridone red, quinacridone violet, sepia, titanium white, and yellow ochre

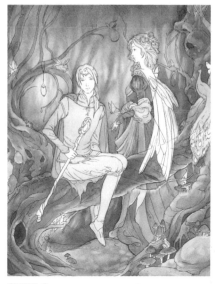

STEP 1 After transferring the drawing, I wet the background and apply a flat wash of yellow ochre and burnt sienna, avoiding the trees and the figures. While still wet, I dab burnt sienna between the limbs and around the figures. I paint the foreground with sepia, dropping in clean water while it is still wet. I apply a mix of sepia and burnt umber over the stones and roots, working around the mushrooms, peacock, and fairies. Then I wet the background and suggest tree shapes with burnt sienna. I paint the woman's dress with a flat wash of yellow ochre.

STEP 2 I paint another layer of burnt umber and burnt sienna over the trees suggested in the distance and darken the trees and roots in the foreground with burnt umber. I create the tree grooves with mixes of browns and Payne's gray. I paint the tops of the mushrooms with burnt sienna, darkening toward the centers. Then I glaze the woman's clothing with quinacridone red, using a mix of cobalt and purple for the underdress. I cover the man's clothing with yellow ochre and his cape with phthalo blue and purple.

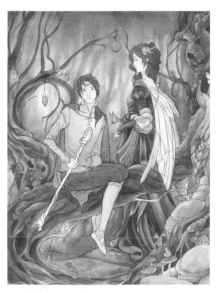

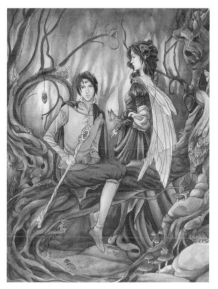

STEP 3 I add more texture to the tree bark and tone to the foreground with mixes of burnt umber and Payne's gray. Then I begin layering washes on each area of the painting to build up color. I use phthalo blue and phthalo green for the man's outfit, letting the yellow show through in areas. I shade their hair with burnt umber and their skin with burnt sienna. Next I select colors for the forest creatures based on the clothing to provide a sense of unity in the painting.

STEP 4 Using purple and Payne's gray, I paint a light layer over the trees in the far background. I add form to both of the faces using light burnt sienna mixed with a bit of quinacridone violet in darker areas. I define the folds on the clothing by building up layers of wash, allowing the glow of the yellow ochre to show through. I continue building shadows and texture on the tree bark using Payne's gray, and I touch the tops of the mushrooms with quinacridone red.

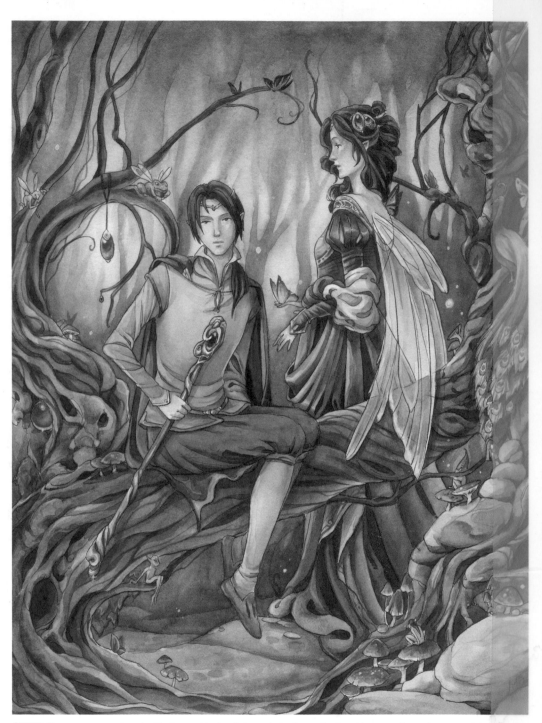

STEP 5 I use titanium white to add a few sparkly white lights in the background. I also add spots on the mushrooms, and I highlight the tips of wings and the folds of the clothing. The white highlights should be the last step, but I decide that the painting does not look finished. To increase contrast, I darken many of the shadows, such as the clothing folds and tree bark grooves, with the same colors used previously. I add more cracks and gaps in the tree bark using sepia and Payne's gray. I also darken the man's tunic and legs with phthalo blue and a little purple. To add color to the top and bottom of the woman's wings, I touch in quinacridone red. Finally, with a very pale wash of purple and quinacridone red, I subtly strengthen the shadows on the faces.